For Catherine

45
AMAZIN
RAH

10.13.92

D1533375

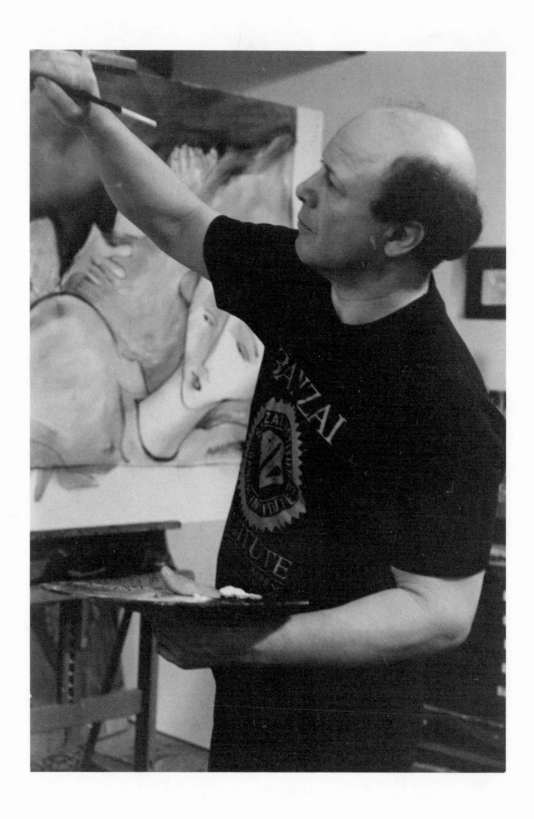

Pure Gesture

E. J. Gold

Text by Linda Corriveau
PhotoArt by Nona Hatay

GATEWAYS FINE ART SERIES

Pure Gesture is Volume Two of the Gateways Fine Art Series

Series Editor: Linda Corriveau
Designer: Nancy Christie
Photography: Willem de Groot and Jeff Case. Frontispiece and
 incidental portraits by Mariette Fournier

Front Cover: E.J. Gold, *Footloose and Fancy Free*, Pastel on Roma, 1977.
Back Cover: E.J. Gold, *The Horn Player at the Blue Note*.
 Pastel on Arches, 1987. Serigraph on Arches, 1988.

Copyright ©1990 by Gateways
Illustrations ©1990 by E.J. Gold
PhotoArt ©1990 by Nona Hatay
All Rights Reserved. Printed in the U.S.A.
First Printing

No part of this publication may be reproduced or transmitted in any form or by any means, electronic or mechanical, including photocopy, recording, or any information storage and retrieval system now known or to be invented, without permission in writing from the publisher, except by a reviewer who wishes to quote brief passages in connection with a review written for inclusion in a magazine, newspaper or broadcast.

Inquiries should be addressed to:
Gateways Fine Art Series
PO Box 370
Nevada City, CA 95959
(800) 869-0658

LIBRARY OF CONGRESS CATALOGING-IN-PUBLICATION DATA

Gold, E.J.
 Pure gesture : macrodimensional glimpses of other realities / E.J. Gold; text by Linda Corriveau.
 p. cm. — (Gateways fine art series; v.2)
 ISBN 0-89556-087-9. — ISBN 0-89556-062-3 (pbk.)
 1. Gold, E.J.—Themes, motives. 2. Art, Zen—Influence.
3. Gesture in art. I. Corriveau, Linda. II. Title. III. Series.
N6547.G615A4 1990
741.973—dc20 89-23642
 CIP

Table of Contents

Introduction

Although innumerable stylistic experimentations have led E.J. Gold in many directions over the years, it is the use of figurative gesture that has become his trademark. Originally immersed in the New York school of Action Painting, Gold soon disassociated himself with it because of a fundamental divergence; he leaned toward figurative gesture whereas the New York school depended heavily upon the abstract.

Gold's view of abstract art was tainted by the fact that he felt it attracted neurotics while classical values and skills appealed to those who weren't compulsively avoiding figuration. This distaste for neurosis was sparked by the fact that Gold viewed Pollock with whom he had become acquainted through his family as an angry, self-indulgent juvenile who was disappointed with Thomas Hart Benton, his surrogate father.

Since that time Gold has maintained that abstraction feeds the artist who cannot draw and the collector who cannot choose, which is not to say that he never works in the abstract mode, just that he knows the weaknesses it often encourages.

By the late fifties, New York was feeling more and more like a wasteland for Gold who, though he was stimulated by the living masters around him—Pollock, de Kooning, Kline, and Rothko—and the younger generation of artists who were yet to be famous, was not inclined to work along the same lines. The alternative of Hans Hoffman was equally unappealing. Gold wanted to develop a classical background and New York didn't seem to be the place where this would happen.

So he packed his bags and moved to California to find others who were exploring the figurative, and find them he did. Rico Lebrun, an imposing man who was to become an inspiration to the budding artist, and the circle around him; Fritz Schwaderer and Hans Burkhardt; Shiro Ikegawa, Robert Hansen, Jack Stuck, William Bradshaw, Roger Bruinekool, Vic Smith, Max Cole, Willie Suzuki, a group of

artists which, including Gold, came to be known as the California Nine and with whom he would exhibit during the mid to late 60's.

Since defining and refining his artistic choices, Gold has produced thousands of gestural images with the ease of a magician wielding a wand replete with mysterious techniques, all the while producing solutions to many artistic problems encountered in late twentieth century painting and sculpture.

Using the category of gesture as a touchstone, it is fascinating to realize that hardly anything of Gold's work escapes this element. Mastery of gesture is the basis of his ink drawings, oil paintings, pastels, gouaches, crayon sketches, linocuts, serigraphs, lithographs, and sculptures. Everywhere and in all forms he draws bold and irrevocable lines, energetic controlled explosions which burst forth on paper or canvas with unrestrained decisiveness.

This book will introduce the reader to a wide assortment of works. The first part is devoted to Gold's pastel drawings. Particular emphasis is given to this medium because Gold favors it and because it shows the bare bones of gesture; the second part discusses charcoals, ink washes and, most importantly, large oil paintings, identifying their underlying gestural structure and reliance on strong drawing skills.

Gold suggests disconcerting realities and asserts himself as a master of atmospheres and moods. He is an artist who boldly—and often humorously—experiments with form, color, perspective and texture in such a way as to challenge most perceptual and aesthetic expectations. He subverts familiar spatial definitions, relations and recognition patterns and forces the viewer to shift subtly into new categories of perception which bypass familiar

axes of direction and dimensional laws predicated on traditional concepts of space. For this reason he should be regarded as a perceptual scientist.

These drawings are the culmination of a succession of steps which Gold has taken over the years to question perception and perspective in both aesthetic and philosophical terms. In a broadcast interview on art, Gold has stated quite plainly that he treats art as a science. In his most accomplished compositions, he successfully denies perceptual context and perspectivist reference and thus forces the viewer into new modes of perception. These breakthrough works open exciting possibilities for further artistic explorations.

The nature of the line is to be free from spatial barriers. The line establishes borders between limits, though it has no limits or borders which are not its own; it delineates boundaries and acts as an interface between planes or dimensions.

The line has the power to extract order from chaos, to invent recognizable objects or figures, to create patterns out of amorphous energy fields. Under the guidance of Gold's disciplined hand, it follows transdimensional routes, crisscrossing the paper surface in a multi-dimensional fugue.

The line also has the power to evoke timeless symbols, to function as a vehicle to capture form and meaning from other dimensions and affix them in a framework with which we may be more familiar.

Gold uses lines as a matrix for the emergence of buried images and patterns. He draws as he sculpts. During an interview which took place in 1983 in New York City—which he had not returned to since the sixties and where he was conducting a workshop on art—

Gold explained how he attempted to uncover the sculpture in the stone, to let it emerge rather than impose a predetermined form on it irrespective of its qualities and characteristics.

This approach carries over into his works on paper. Lines laid down in apparently haphazard and random direction, alternating between sinuosity and angularity, contain in themselves an image, a pattern which the artist uncovers and brings to the forefront. With a deft hand and a discerning eye, he guides the process of transforming an amorphous shape into a penetrating vision, unveiling that which is still shrouded by non-existence and inchoate matter.

Gold sets himself purely graphic objectives in his gestural drawings. He concentrates exclusively on the power and meaning of line as a medium of limiting form, volume, and space, and as an indicator of movement. Line becomes for him a highly complex and summarizing method of virtuoso presentation. When studied superficially, his works reveal little of this complexity. In what seem to be simple outlines, Gold traces the essential features of his figures, condenses and abstracts forms, suppresses or minimizes details, invents others, and conjures up his own highly stylized visual world.

He literally "in-forms" his drawings, revealing the form captured within the original action gesture. The "in-formation" process operates according to the imagination and intention of the artist but also according to a subtle knowledge and manipulation of energy distribution. Gold captures waves and patterns of energy as they circulate free form before being bound by a circumference which he himself imposes once he has established the nature of his drawing. This partially accounts for the ener-gy and dynamism of these artworks.

Neither pastel as a medium nor gesture drawing as a technique should be considered preliminary steps for larger and more developed paintings. Gesture is a focal point to Gold's work. He uses it to learn about forms, objects, limits and the transgression of laws in the "time-space discontinuum," to use Gold's phrase. The gesture pieces are all raw expressions of an attempt to capture an aspect of reality which is usually masked.

Gold rarely, if ever, uses models. His artistry relies on the free, inventive creation and interpretation of his subject matter. His graphic work bears witness to this life-long questioning of forms and limits. His drawings reveal a great creative imagination, personal working methods, and a mental and emotional commitment in pursuit of life-long artistic objectives.

Gesture allows us to see with the eyes of the artist. These gestural works are doorways to perceptions that we can use to expand our vision. The whirring lines go from one dimension to another producing distorted figures. This crossover is something we may not be familiar with but which contributes to make his work fascinating. The morphologies we encounter here are attempts to translate complex topological characteristics which are not typically represented in artistic form and for that reason seem very unusual and disconcerting at first.

Gold's vision perceives how energy fields are bound together, the paths that particles follow and the waves which they bounce off of, almost as if he enables us to see the dance of Maya in a two-dimensional variation of a Wilson Cloud Chamber. By doing this, he forces us to reevaluate our perception of the time-space discontinuum by interweaving fragments

of unconnected realities into a collage of chambers within chambers where dimensions are stretched or diminished according to necessity. Infinite spaciousness and atmospheric vastness are characteristic of most of his gesture work.

The gestural drawings are recognizably reductionist in manner, and adhere to the principles of Reductionism that are enunciated in the *Manifesto of Reductionism* which Gold co-signed with dozens of other artists. Because of its importance and pertinence in regard to this material, the *Manifesto* has been included as an appendix at the end of this book.

Though there are overtones of Surrealism in many of the forms we will encounter in these pages, the influences Gold is indebted to stem primarily from such artists as Rico Lebrun, Fritz Schwaderer, Hans Burkhardt, Bentley Schaad, some of whom we've already mentioned, and Franz Kline, during Gold's earlier period in New York. Gold also acknowledges science fiction writer, Theodore Sturgeon, for insight into the reality of artistic production and creativity.

But if any single category were ascribed to Gold it would have to be that of a classicist, for in the final analysis, even though he paints in the abstract with as much ease as he exhibits when working in the representational, he returns again and again to the human figure as an axis around which his themes revolve. His incursions into exaggeration, distortion and asymmetry are in fact departures or digressions from a line of proportion and equilibrium which he knowingly violates time and again with steadfast determination, craftsmanship and humor.

In addition to his talents as an artist, Gold is an internationally recognized author of books in the area of science fiction and inner transformation. Over the past several years he has turned to the idea of the labyrinth as a working concept which has proved very fruitful for a practical approach to what he calls the "macrodimensions." Familiarity with his written material enhances one's appreciation of his art.

His talents don't stop there however. Gold is also a world-class composer and musician with many successful recordings in the fields of jazz and classical music to his credit. He's also been at various times stage director, dancer, jeweler, recording technician, magazine editor, stage magician, stand-up comedian, and a consultant in a wide variety of fields including stock portfolios.

One of the keys to understanding the gestural drawings, more specifically the figures, is the science of posture. Posture sets the mood, atmosphere, tone, and ultimate nature of these figures, determining also their place of origin whether it be the human realm or another realm slightly removed from it.

Gold possesses an undeniable mastery of the language of posture. His preoccupation with this subject has led him to make prolific use of figures. Posture is so profound and central in his work that entire sections of his *catalogue raisonné* currently in preparation, including some thirty thousand drawings spanning the years 1947-1990, have been systematically organized around his figures according to the nature of their postures and activities.

Posture and the gestural figures which convey them can be viewed as keys or tools for labyrinth voyaging. They invite us into sectors of the reality spectrum that are not often explored by humans. By doing this, Gold is enticing us to delve into the outer limits of the macrodimensional labyrinth.

These images can be considered examples of objective art. They are capable of

activating specific chords in each one of us and triggering a response on the deepest level of our beings. They do not address the superficial outer personality but the living self which embraces wholeheartedly the strangeness of this art.

By feeling what it was like to *produce* the artwork, by feeling what it was like to *be* the artist, we can learn what the artist learned from his experiment. In that sense, an artwork is a way of conveying a state to the non-casual viewer so that they can access it too. Decorative paintings don't involve special states, but objective art does.

The limiter to this is that the artist can touch us only to the extent that there is already something inside us that corresponds to this experience. If one has the artist inside oneself, one can sense and see the same thing.

The distortions which Gold's figures often undergo are of specific types. Some of the more typical ones include small heads topping large bodies, bodies with large hands and especially large feet, oversize teeth, wispy silhouettes, or oversize rumps. One is often given the impression of looking up a great distance from below or looking across a great distance. The point of view of the figures is very different and more subtle to grasp. Their viewpoint is usually the reverse of ours; they experience the descent from above and fully sense the squeeze into uncomfortable shapes.

Iso-magnification, borrowed from Kline, represents a central facet of Gold's art, a means for him to invite us to the edge of perception offering us visions of the strange and unfamiliar. We will see how it is applied again and again.

Although many of these images have a raw quality, and are often full of satire, they have nothing to do with cartooning. They rely on exaggeration of detail only to penetrate and capture the feeling of rarified spheres.

The attention to and amplification of detail is what brings the idea of the preliminary sketch to mind when one first sees these ultra-limber exercises in precision and deception—and even for the artist it is sometimes difficult to determine what is intentional and what is accidental. Though lines may fall haphazardly when Gold first puts them down on paper with a single complex gesture, what follows usually obeys strict rules of composition and assembly.

The drawings as a whole are transparent renderings of energy patterns which crisscross from one architectonic plane to another. One could almost say that they are faithful reproductions of cosmic ley lines or *feng-shui* lines, to use the more traditional Chinese expression. The artist combines his visionary predispositions with his abilities to translate into understandable terms that which he sees with his inner eye.

These works have a profound spiritual basis, like the art of *sumi-e* and of much Abstract/American and Figurative/German Expressionism; they also posit the existence of higher dimensions which they translate into visual forms that remind us that we can participate in the higher and more subtle moods evoked. Or, they may force us to realize that we have just changed reality structure, that we are viewing from a higher dimension. Occasionally they can evoke a profound longing capable of nurturing something deeper in us.

Gold also leans on pure symbolism that exists independently as archetypes which appear spontaneously in his work when he acts as a mediator, like Prometheus, the fire-bringer, or Hermes, the messenger. The best of his work has an indescribable quality and its

effect is profoundly disturbing. These images stir something unnameable. They awaken an inner response to an undefined otherness that flees as we approach it. Or they may have a strange compelling quality and an unexpected intimacy that draws us in.

The book has been organized in groups of images with a common preoccupation. Sometimes they are part of an actual series that was produced at the same time and sometimes they have been assembled for reasons which will become obvious to the reader. This compendium should reflect the diversity and constants in Gold's motifs, while faithfully mirroring the conceptual framework within which he operates and his inimitable sense of humor. Many images tell a story or have a narrative quality which explains in part why it is so delightful to sit with them and interpret them.

The larger more complex works, in particular the oils-on-canvas, synthesize many facets of Gold's experimentations thus enabling us better to understand him as a perceptual scientist who uses art as his investigative tool.

It is not possible to present an exhaustive survey of his important works here. The second part of the book offers only a superficial sampling of their broad spectrum, leaving it for others to consider the subject of his oil paintings in greater depth.

The book opens with *Portraits of Another Kind,* a kaleidoscopic parade of figures which tell us something about Gold's ability to assume viewpoints. The serenity which we can sense in many of these stems from a depth and life which the artist has given them and which makes them one more beautiful than the other. We have only to think of *The Hermit* to understand the sublimity of emotion that is alluded to by many of these drawings.

The second sequence offers *Lankies and Friends* where Gold toys with lithe, translucent figures, relying on a counterpoint of lines and opaque surfaces to create a shimmering illusion of otherworldliness.

With his *Transparent Energy Fields,* he heads in the direction of abstraction while at the same time introducing us to very figurative, airy and graceful dancers which glide through the pages. *Oh Feet Don't Fail Me Now* is a fine example of the free form reductionist style.

Gold's theme development has led to some of the more remarkable work he has done with iso-magnification and Reductionism. His *Ladies With A Special Curve* provide rich examples of how graphic details can be amplified, maintained, discarded or transformed. From *Beyond All Reason* to *Taking It All In Stride* the artist proves that he is never at a loss for developing interesting and imaginative variations.

The following chapter, *Whimsical Beasts,* alternately delights the reader and expands our horizons. The beasts share in a remarkable forcefulness and intensity. They also exhibit a sense of humor and playfulness which turns them into irrepressible messengers of fancy. In marked contrast however, we discover the ominous feeling conveyed by *Horse of the Apocalypse,* reminding us that behind these amusing images is an accomplished classical foundation quite capable of conveying deeper, darker associations and meanings.

Some of the most endearing of Gold's gestural pieces are his portraits of *Svelte Musicians.* Being himself a composer and musician, it is not surprising that he manages to capture the essence of sound in this series. These drawings are delightful in their musical sensitivity and suggestivity. They also represent

the epitome of reduction and contraction. They are all, without exception, graceful silhouettes bending to the sound of music. Their curves flow with the ease of a crescendo and their bodies are vehicles used to suggest the music they've invented. *Horn Player at the Blue Note* stands out as a favorite.

The *Kickers and Jumpers* display a dashing sense of humor, fun and enjoyment. These playful characters offer us vicarious exercise such as most of us have never dreamed of. *Kick Up Your Heels...and Your Toes* wins the prize for exuberance but *Foot Loose and Fancy Free*, the cover piece, never ceases to enthrall and lift the spirit in sheer delight at the levity it conveys.

The *Bigfoot and Bighand Family* emphazises iso-magnification of detail. This series is among the most daring in the genre. It breaks away from representational constraints by introducing us to characters that have wild and fanciful distortions of every imaginable kind. *Grospied* is a delight, as well as *Sky Earth Lightning Shaman*.

Sailing, Sailing Over the Bounding Main is not only amusing but also intelligent. Of course, it's hard to ignore *The Dog In The Moon Is Now In Sight* as well as *Mambo Italiano* which, with their biting humor, are among the very best reductionist pieces Gold has ever produced, not to mention *The Conductor Before Her Orchestra* which is refreshingly charming. These are all incomparable macrodimensional visual gateways.

The first part of the book ends with *Characters and Voyagers*, a compendium of portraits which reveal angular strokes and yet another facet of whimsy. *Panhandler* introduces irony, while *Flying Boobs* leaves us on a flight of fancy. It is an accomplished work which

gracefully embodies the tenets of Reductionism.

The second part of the book opens to a more expanded view of Gold's art by introducing us to his charcoals, another medium in which Gold excels. In *Macrodimensional Models* we encounter nudes such as *Leaning Nude* and *Phantom Form* which are stunning. The portraits that follow are typical of his moody, brooding creations that leave us with a haunting feeling. *Peter Lorre, Jr., Inside, Outside* and *Figure with Crutch* are dramatically effective. Charcoal is the medium which shows more than any other the influence of Lebrun.

Next comes a series of ink washes, *Macrolandscapes* showing the abstract side of Gold's art which we have so far not considered. The dynamic quality of this imagery makes it all the more appealing. The Eastern influence is nowhere more apparent than here, especially in the series of *sumi-e* drawings, the *Movement Gestures,* I through V.

The three chapters which follow introduce us to Gold's larger oil paintings. The *Planar Contiguities* illustrate the extensive experimentation he has done over the years with forced perspective and color compression. Gold establishes here an ambivalent figure/ground relationship which denies classical illusionism and sets up a visual dynamic that is present in each one of these beautiful canvases. The mood of *In Repose* and *A Wee Slip of a Girl* is serene and generally typical of this non-prismatic series.

The *Sanitarium* series contrasts sharply with the *Planars*. It is one of the most powerful Gold has ever produced. These disturbing images evoke eternal, frozen spaces and a feeling of being alone that penetrates and haunts the viewer. *A Bottle of Spirits* and *Sanitarium Blue* inspire some of the more terrifying aspects

of eternity, while *Red Bottle* is decidedly more serene, suggesting perhaps an internal, invisible, reconciliation with beingness. The metaphysical reach of these canvases is perturbing.

The last chapter brings us into the world of *Odalisques*, the most mystical of all of Gold's works. In very large, colorful canvases, we are brought to a deeper understanding of the mystery of the figure sitting alone in a chamber. The results are quite unexpected. A mood of serenity and tranquility inhabits most of them. *Pomegranate* stands out as the paroxysm of inner peace, with its mate, *Grand Odalisque,* a close second if not as remarkable. A few gouaches were included in this chapter for the interest of comparison. This is one instance where Gold worked from large scale down to small scale, the oils and acrylics preceding the smaller gouaches.

The images are accompanied by a commentary which alternately analyses or interprets them, and provides background information about the series to which they belong, or the intent of the artist in producing them.

Juxtaposed with this material are numerous quotes from the artist/scientist enabling us to glimpse some of his own thoughts about his work, influences, direction, intentions, and the process of artistic creation and scientific experimentation. A further series of quotes

from artists, collectors, connoisseurs, art dealers and friends offers yet another point of view on the nature and importance of his art.

Extraordinary experimental photographs by Nona Hatay who gained fame for her unusual portraits of Jimi Hendrix, Tina Turner and many other rock stars, have been used abundantly throughout the book. Hatay spent a week visiting Gold in his studio and photographing him in every mode he went through during her stay, from composing music and doing mixdown, to painting and sculpting. Notes and comments she has made about their fruitful encounter are scattered throughout the book.

Hatay and Gold recently combined their talents in a bold exhibit full of humor and originality. Hatay's photographs provide a view of the artist by another artist, and are a fascinating addition to the book, broadening its spectrum and deepening its penetration of this multi-leveled explorer.

In contrast to these highly stylized and imaginative photographs, the subtle and intimate portraits by Canadian photographer, Mariette Fournier, capture another facet of the many moods of the artist—the warmth behind the scowling or the clowning masks.

Biographical notes have been included at the end as well as an alphabetical listing of all of the art works included here.

Pure Gesture

As an experimenter, Gold proceeds by systematically exhausting the elements contained in a visual motif, extracting from it all the latent forms that reside in it. Because of this, one characteristic of his work is that it is generally most understandable in series. When Gold produces an image it is rarely isolated and out of context. Quite the contrary—one image will suggest and yield dozens of others.

This systematicity is attributable to a desire to know all the parameters of any visual sequence and to control and possess them. This requires discipline and patience, but also love for his work.

As a perceptual scientist, Gold turns his attention to the effect of art on the observer. By exploring models of perception he is able to produce subtle alterations in his art which contravene culturally implanted sensory expectations and force the viewer to shift one's mental-emotional posture.

We will now embark on a tour of Gold's pastels through some of the labyrinthine mazes he has constructed for us to navigate through.

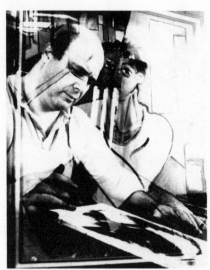

PhotoArt by Nona Hatay

"The interesting thing about art is that what you see is not as important as what you feel."

E.J. Gold

Portraits of a Different Kind

It seems fitting to begin our introduction to E.J. Gold's gesture work by examining his figures and portraits. These are important because they lay the groundwork and open the door to more complex pieces. In fact they are the foundation on which much of his opus rests. At the same time, they are the distillation of explorations from large scale down to small scale.

The portraits should not be looked at from a psychological point of view because, if anything, Gold's art is blatantly non-psychological. Archetypal, symbolic, labyrinthine and macrodimensional are more fitting qualifiers.

These figures are vehicles for the element of mood in its broadest perspective. They integrate a myriad of higher emotions which they alternately express or allude to in the most subtle and diversified ways.

The function of mood is well illustrated in *The Hermit*. In this piece, a pervasive atmosphere of inner collectedness draws us in closer to something intangible. Two lines encircle the figure in an accidental effect giving the impression that they are going before him in the outside world in the manner of a powerful energy field swirling invisibly around him. This amalgamates two worlds which are normally far apart.

THE HERMIT (Facing Page)
Pastel on Sennelier, 1972.
Lithograph on Arches paper

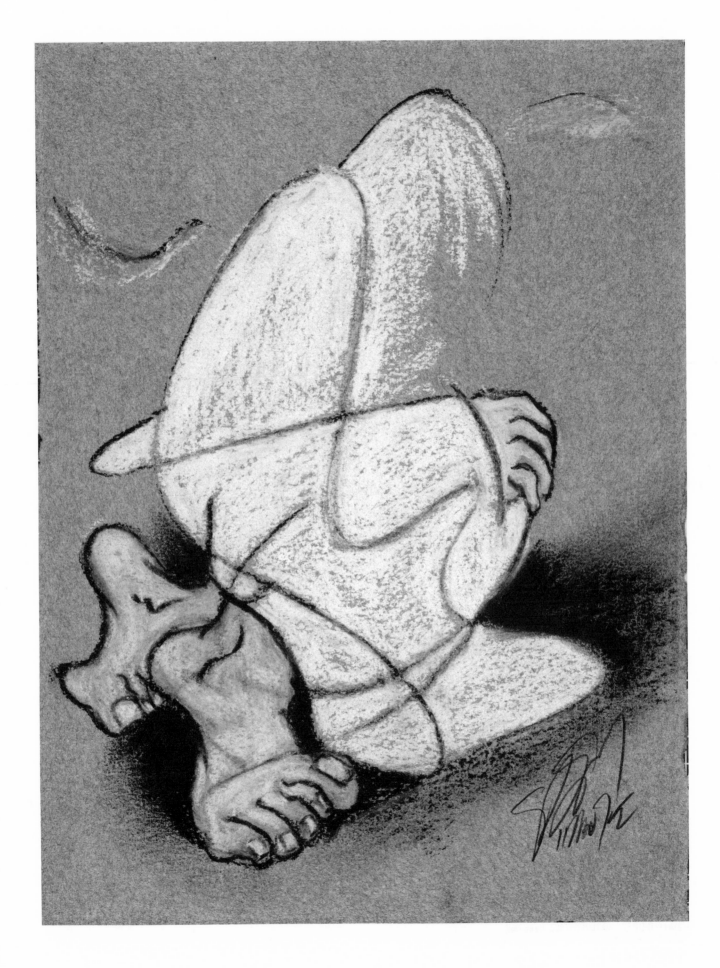

At any sitting, Gold can develop a series of images of the most diverse nature, or they can be quite similar as when he is exploring and penetrating a motif, scrutinizing and approaching it from every angle, from every point of view.

The energy in the composition on the facing page is very contained and balanced. The lines criss-crossing in every direction throughout the body lend it an intriguing transparency and three-dimensional quality as well as an electric resonance.

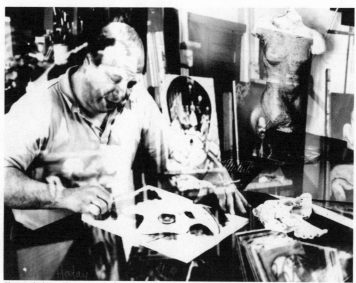

PhotoArt by Nona Hatay

"In the New York School, the big accent was on gesture and action. It was called action art. I've taken that to mean something quite different. I've taken action into the originating lines, then I ignore them and work from there. I try to find something within that. So I take the first action, and I see if I can develop something from it."

—E.J. Gold

A MATTER OF DELICATE BALANCE (Facing Page)
Pastel on Sennelier, 1977.
Lithograph on Arches paper

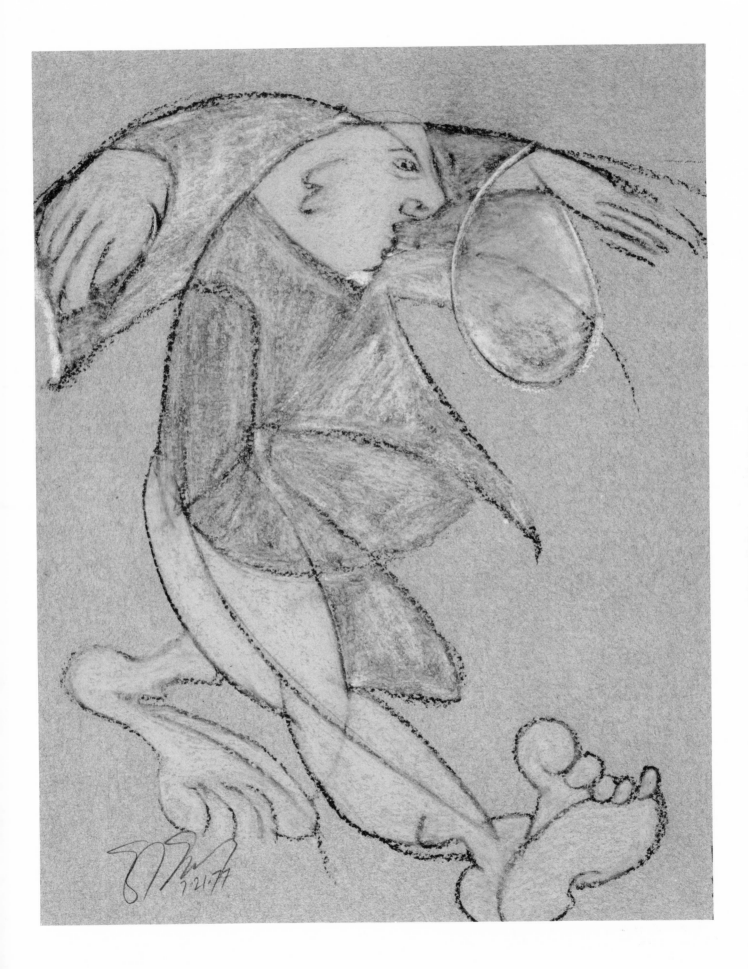

"Art should reveal another world, a different dimension, a different way of seeing. It should strip the ordinary senses away and show the world which is unperceivable with ordinary sight and feeling. This does not require profound academic training. Many examples of such work can be found in the crudest of naive artists. Training and proficiency in this regard mean nothing.

"Art can only reveal this to the extent that the artist is able to transcend the boundaries and limits of primate perception. Art which appeals to the primate self reveals nothing."

—E.J. Gold

"I admire Gold for his diversity and creative instinct. His pieces are deceptively simple, yet extremely powerful. As with Hendrix, what draws me so strongly to Gold is his daring to experiment, to incorporate the elements of chance, to inspire."

Nona Hatay

This fluid composition has all the characteristics of a dimensional transgressor such as the airiness and transparency of the figure as well as the distortions in proportion.

Dimensional transgressions occur when the barriers between them break down temporarily and we are able to make incursions into spaces for which bodies, as we know them, are not suited, thus producing, among other things, distortions to our outer shapes.

This drawing allows us to see where the gesture has stopped and where an intentional form has been drawn in, sometimes from an existing line and sometimes not.

SWEPT AWAY ON THE WING (Facing Page)
Pastel on Sennelier, 1974.
Lithograph on Arches paper

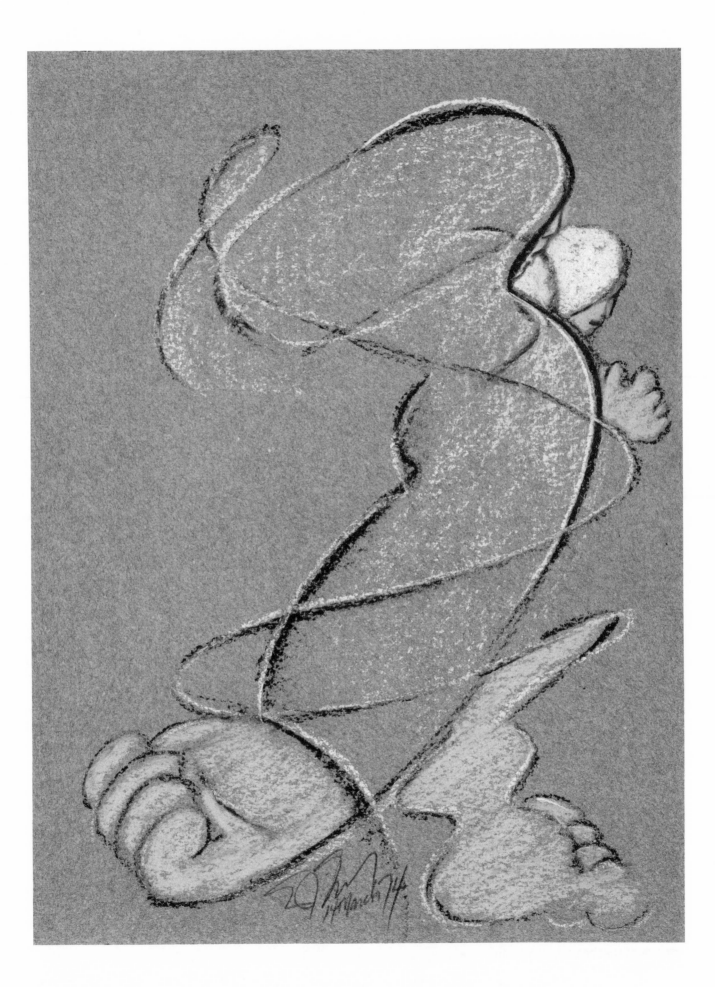

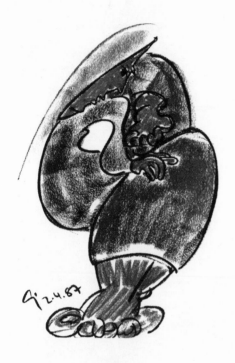

"I have been profoundly moved by Gold's work. There is something haunting about its beauty and simplicity. It strikes you at gut level. He's a real artist."

Donald Suckling
Art Collector
Wigan, England

Most of Gold's figures inhabit abstract and empty spaces, spaces with no reference outside themselves, or outside the picture plane. When there are walls, doorways, or corridors, as in the *Sanitarium* series, the *Open Doors*, and the *Odalisques*, they are purely symbolic. The setting is practically absent.

Texturing, wallpaper or a single stripe may decorate a surface. A fire hydrant or a lamp-post may indicate a street. But usually we wonder where we are. What we are looking at. Whether we are indoors or outdoors. But mostly we find ourselves in bars, cafés, kitchens, living rooms, bedrooms, antechambers, or institutional waiting rooms. Even images from the *City in the Sky* series, though representing buildings and streets, are floating in the middle of nowhere, suspended in a void.

The figures themselves are, for the most part, archetypal, self-generated from a gesture, created out of nothing or out of minimal means. They stand alone and, just like the spaces they inhabit, have no reference outside themselves. At the deepest level it is true to say that the figures *are* the chambers. This is particularly true of the *Odalisques*, *Planar Contiguities*, and *Sanitarium* pieces which have been included in the second part of the book.

In contrast to this depth of emotion and with a priceless and irreverent sense of humor, Gold will often attribute an incongruous title to a beautiful drawing demonstrating his playful tendency to catch the viewer off guard and shock him, while at the same time never taking himself too seriously. This is what he has done on the opposite page.

In marked contrast, the posture of introspection is reflected in *Gazing Into Center* which emanates a mood of tranquility and spiritual concentration, the subtle world of higher beingness.

GAZING INTO CENTER
Pastel on Rives, 1987.

HEY, THERE'S SOME DOO-DOO ON THE PATH (Facing Page)
Pastel on Sennelier, 1972.

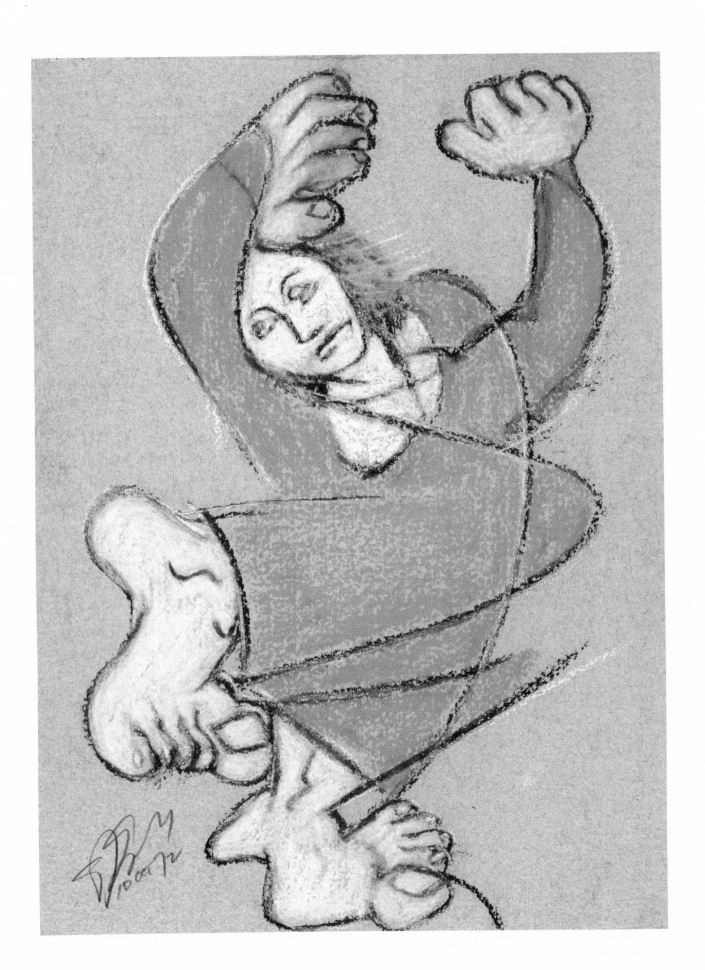

"Creative spontaneity, inspiration, titillation, vigor and vibrancy enhance the sense of beauty in sounds, colors, forms, words and movements which are the quintessence of E.J. Gold's world of the arts."

Jim and Gloreen Rowe
Art Collectors
Santa Barbara, CA

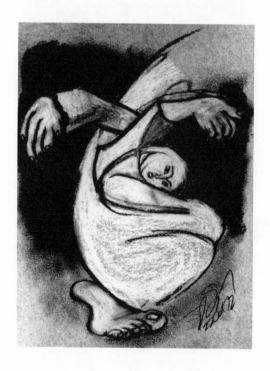

Once an artwork is created, the image has its own life and impact, which depends upon visual content; we basically react to what we see.

With abstract and experimental art it may often be difficult to know what we are looking at, so a title carries a lot of weight. Artists are well aware of this and often avoid the issue by giving an artwork a number or an insignificant title as in many of the painting series produced by Rothko, Albers, and de Kooning. This is because of the terroristic *power of the Word*, the *Logos*, which prevented most of the New York Abstract Expressionists from giving significance to their work. In an earlier surrealist approach to the same problem, Magritte invented poetic *non-sequitur* titles.

The act of naming gives a new dimension to an image and determines to a large extent the understanding we will have of it. *Mayan Pterodactyl Rider* is a good example of a title that forces you to think along new lines. It adds something to the piece. In contrast to this, *Center Stage* seems rather obvious.

The study of myths teaches us that when Adam and Eve were in the Garden, they began to name things. Naming is a way of compartmentalizing the world—defining, enclosing, limiting. It destroys the abstract fluid reality where everything is still blended as one, and transforms the world, in this case the visual world of the artist, into individuated objects and forms. All abstraction eventually degenerates into rigid representation.

CENTER STAGE
Pastel on Sennelier, 1972.

MAYAN PTERODACTYL RIDER (Facing Page)
Pastel on Sennelier, 1972.
Lithograph on Arches paper

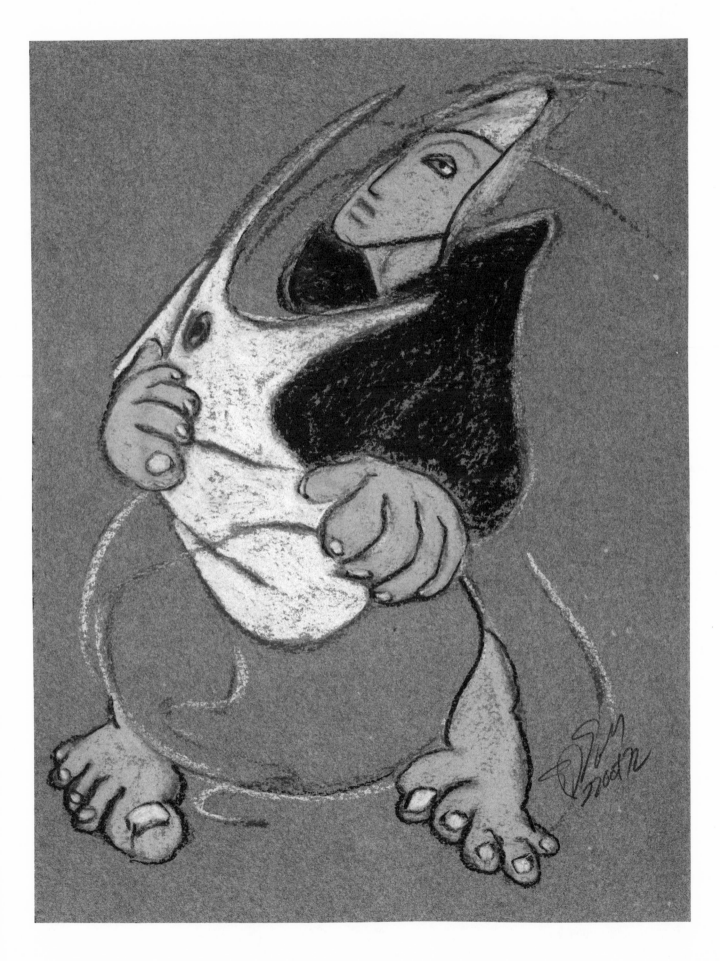

*"E.J. Gold has a great
sense of humor."*

Ron Tristal
Art Collector,
New York, NY

By superimposing a reference outside of what we see, a title can expand the contents of the artwork. At its best it can evoke a mood or an emotion. It can also open up spaces that escaped us, or gently guide us into a deeper level of understanding. So naming has its function and use. It does not of necessity freeze and stultify an interpretation, although it can be a limiter.

How does an artwork get a title? Many of Gold's titles occur as afterthoughts during titling sessions where the artist sits down with hundreds of artworks or index cards of these and dictates titles to his archivist.

Ironically, the difficulties of cataloguing a large body of work generated by such a prolific artist have resulted in several pieces being inadvertently titled twice, and quite differently. This indicates how arbitrary a title can sometimes be. On the other hand, many artworks have been titled almost identically the second time around, so it works both ways.

But in the end the macrodimensional glimpses which this art offers are effective with or without the titles. We don't need to know anything about the figure on the right to sense its transparency, to feel its intense concentration of energy and mass. On these two pages the titles hint at inner moods rather than redundantly describe the outer forms.

The early drawing to the left joins the distant dimensions in an effort to synthesize their union. From the small foot to the large head we can imagine a stupendous distance bridged by this body.

This is one of the few examples of Gold's art which has survived from the sixties when he was represented by Comara Gallery on La Cienega Boulevard in Los Angeles. Photographs of his artistic production from this period are practically non-existent. Gold didn't document his art and Comara Gallery folded after Robert Comara's death a number of years ago. Few records of transactions, buyers and institutional owners are traceable today.

A WOMAN OF QUALITY
Pastel on Arches, 1968.

UNDER THE SUMMER MOON (F. P.)
Pastel on Sennelier, 1974.

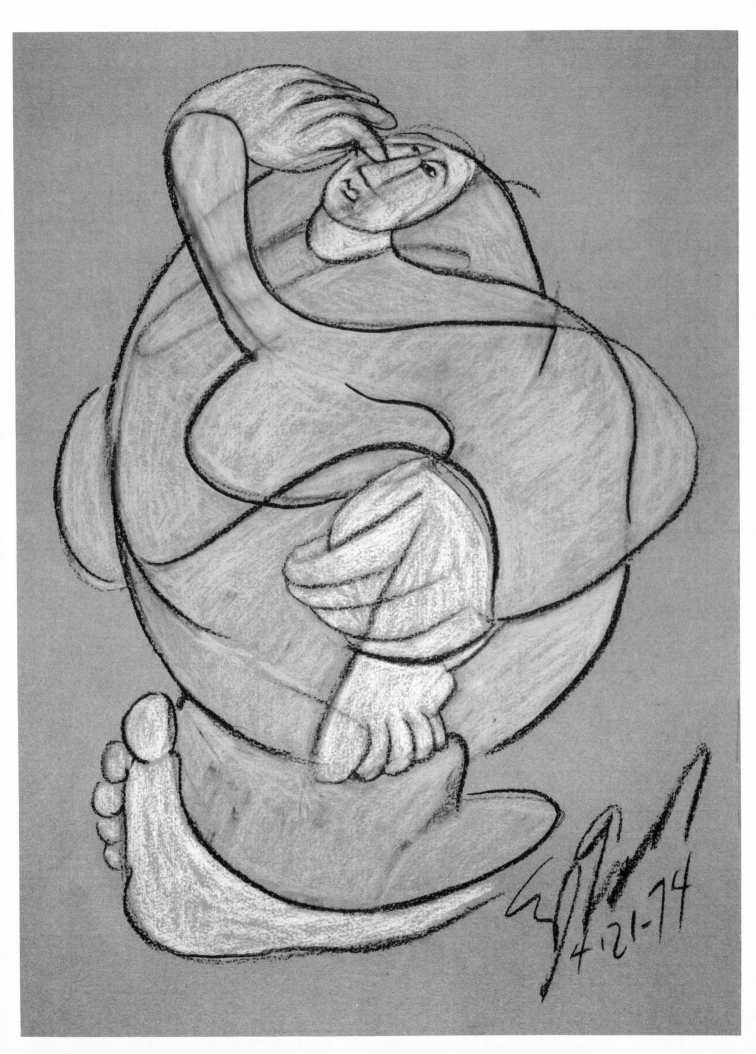

*"I treat dark just like light.
I play with it the same way.
I spill the dark out just as
much as the light. It has
its own force and its
own action."*

E.J. Gold

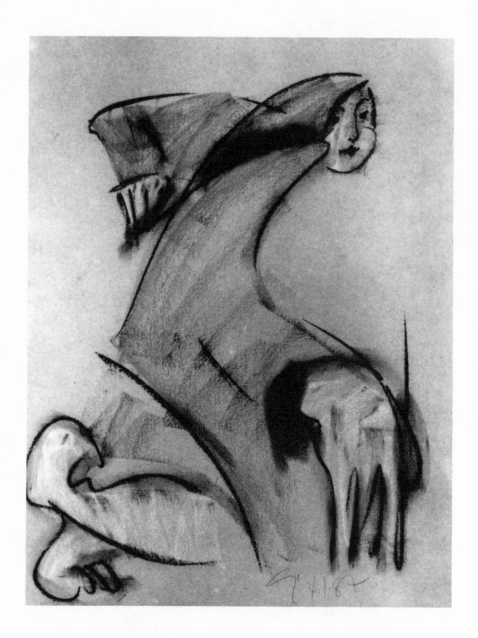

The beautiful composition above has an unrelenting-ly inspiring quality to it. The viewer is gently drawn up the levels of the totem to the place of inner peace and tran-quility of this kneeling figure.

The process of macrodimensional expansion and stretching is well reflected in *The Growing Rest* where we can also get a feeling for what it is like to be un-ceremoniously stretched. The disproportion between the various body parts is due to the immense distance between them.

KNEELING FIGURE
Pastel on Sennelier, 1987.
Han Huskey Collection

THE GROWING REST (F.P.)
Pastel on Sennelier, 1987.
Farkas Collection.

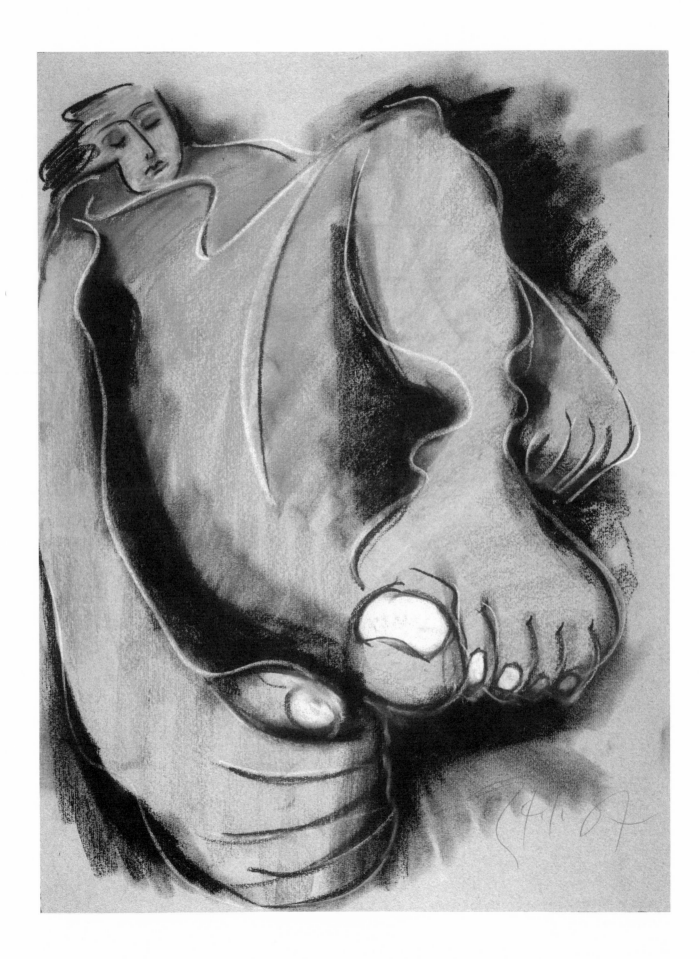

"I begin by getting a good movement of light and dark across the canvas. At some point I begin to search for the effect, but at first I'm not looking for the effect. I'm just working with light and dark.

"I use what I know as an artist when I don't really have anything in mind. Then when I see something, I know if I do this or that the effect will be very good."

—E.J. Gold

"My photo/art essay on Gold is entirely the product of the week I spent with him in November of 1988, accompanying him as he worked in his art studio or recording studio, observing him as he went from one work-in-progress to another.

"It reflects the impressions and visual stimulations of a week's observation of the artist at work in both his art and music studios.

"I found the week I spent at Gold's studio very inspiring. I think his experimentalness and the fact that he goes through so many media made me interested in working with him. He's involved in experimental music, all forms of art, painting, sculpture and prints."

Nona Hatay

PhotoArt by Nona Hatay

The figures on all of these pages reflect Gold's morphological and topological views based on his concept of macrodimensional art. They reflect a vision of the world where matter is considered from the point of view of its transparency and volatility as slowed down light.

The lithe satyr, revelling in his bacchanalia, prances around on one hoof swinging his arms and his horns. Ancient mysteries are brought to life and alluded to in this festive piece which has surrendered to fluidity of line.

DANCING SATYR (F.P.)
Pastel on Sennelier, 1976.
Lithograph on Arches paper.

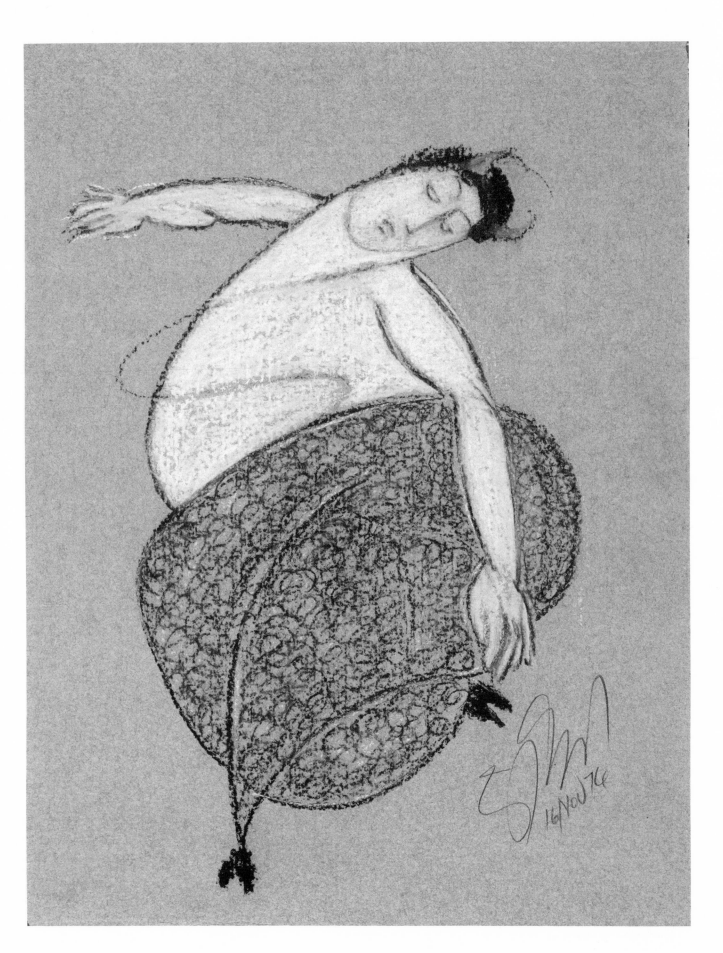

With his usual flair for shocks, Gold has titled this early pastel in marked contrast to its subject matter. The decisiveness of the lines indicate he had already mastered gesture at this point while the exaggerated teeth announce later developments.

But most of all this piece stands out as a unique creation since Gold has produced very few close-up portraits of this type. It relies entirely on gesture to achieve its effect and it is not concerned with exactitude. This makes sense because Gold often quotes Matisse as saying: "Exactitude is not truth."

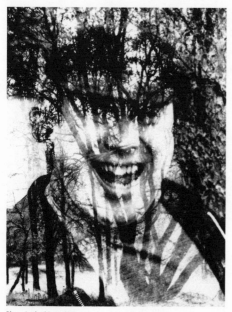

PhotoArt by Nona Hatay

"What I want to do is catch somebody walking around a museum, looking at all the pretty pictures, when suddenly, leaping out at them, from the canvas or the piece of paper, is a hole in the universe, an actual opening. And the macrodimensions bulge into this very restricted, nice and tiny primate space they're involved with."

—E.J. Gold

AN UNDERSTATED COMMENT (F.P.)
Pastel on Sennelier paper, 1972.

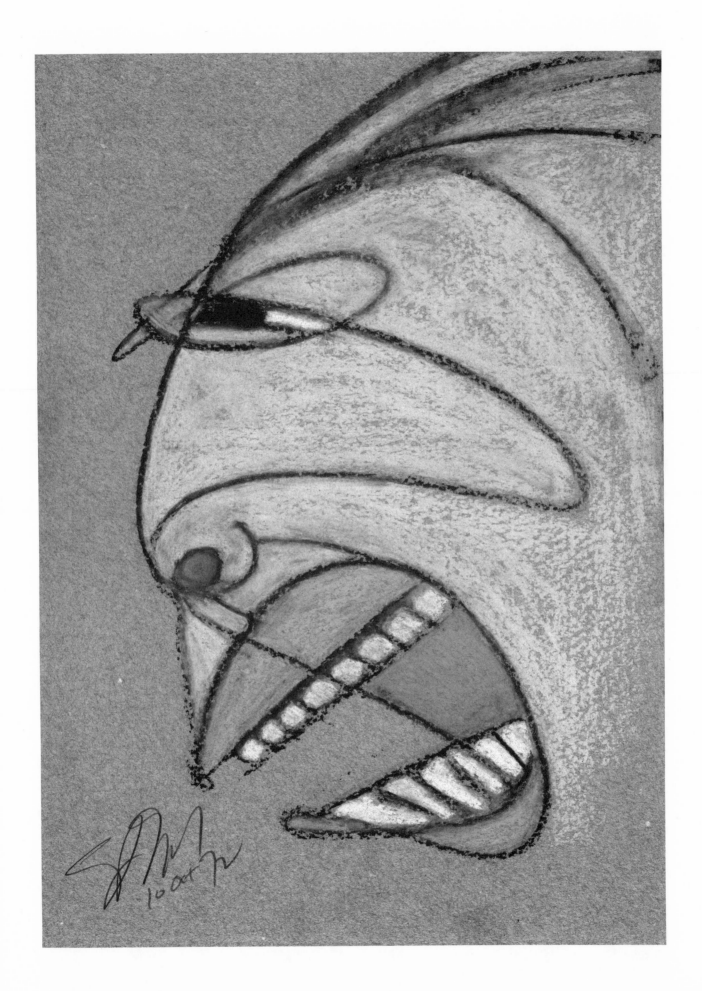

Photo Credit: Mariette Fournier

"The reason I find Gold's work so fascinating is that it contains different views all presented with a sense of humor. "

Devoy White
Art Collector
Sacramento, CA

Lankies and Friends

What is Gold seeing and attempting to render with his fluid line and transparent forms? It seems to escape the mundane, visible world—to defy "gravity," as in the Bauhaus teaching of Paul Klee's *Pedagogical Sketchbook.* Gold's vision may also be considered as a series of experimental perceptions exploring how individuals handle the electrical plasma field which, as a study of physics tells us, is the stuff of which all matter is composed, each somatic type having its own configuration and peculiarities.

Gold contains and compresses these energy fields. A flurry of lines hints at the paths followed by high energy particles. Trails of energy swirl through the body, in every direction, criss-crossing at periodic intervals that correspond to inner unknown rhythms and mysterious pulsations in a post-Heisenberg quantum mechanics body cosmology.

The pastel drawings in this chapter span several decades. They have been gleaned from 1966, 1974, 1979, and 1987, although earlier examples might just as well have been used. They are all examples of experimentations with energy webs. The continuity between these images is indicative of an ongoing penetration into and through a new perception.

With the exception of *En Balance,* the aesthetic basis for these creations is a counterpointing of thin lines, empty space and opaque areas at the extremities of the limbs.

The engaging character we see here is brimming with candor in this understated rendition counterpointing opacity and transparency. We can almost picture the artist winking at us from behind the raised thumb as he holds back from going too far in capturing for us this regal representative.

YO, EL ROI! (F.P.)
Pastel on Sennelier, 1974.

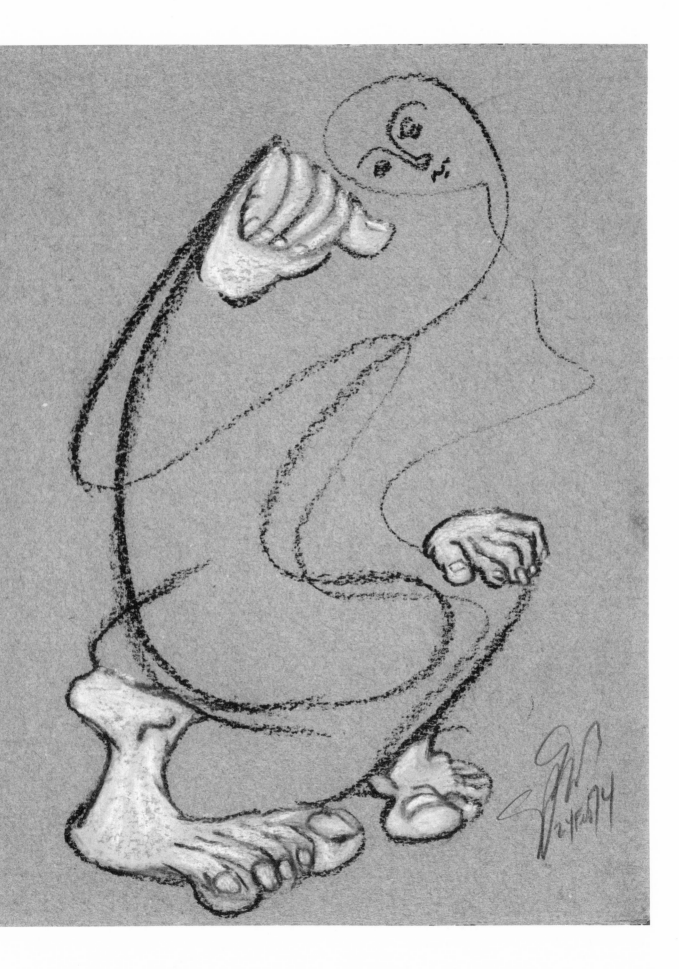

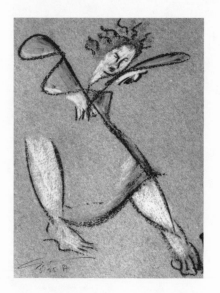

The figure to the right reminds us of a juggler throwing objects in the air and catching them as they fall. One arm is uplifted, the other is symmetrically placed below it. His head is conveniently to the side. This could be a cosmic juggler or a demiurge throwing universes around the way some of us throw ideas around.

The meaning of this figure is unimportant. What counts is that it transgresses normal boundaries and suggests unforeseen possibilities allowing us to expand our own morphologies.

The success of *She Came Down Hard on the Children* is largely dependent upon the floating leg on the left side which counter-balances the rest of the figure and at the same time creates three-dimensionality. The limbs stretched in all directions act as a mirror to the inner convolutions of the character.

PhotoArt by Nona Hatay

"Art is not intended to live forever; to be hung on the wall or peddled in a shop. The art happens at the moment—in the gesture. It is self-completed in the occurrence, and after that, it dies, and its corpse is what we see in shops, galleries and museums."

—E.J. Gold

SHE CAME DOWN HARD ON THE CHILDREN
Pastel on Sennelier, 1987.

EN BALANCE (F.P.)
Pastel on Sennelier, 1979.

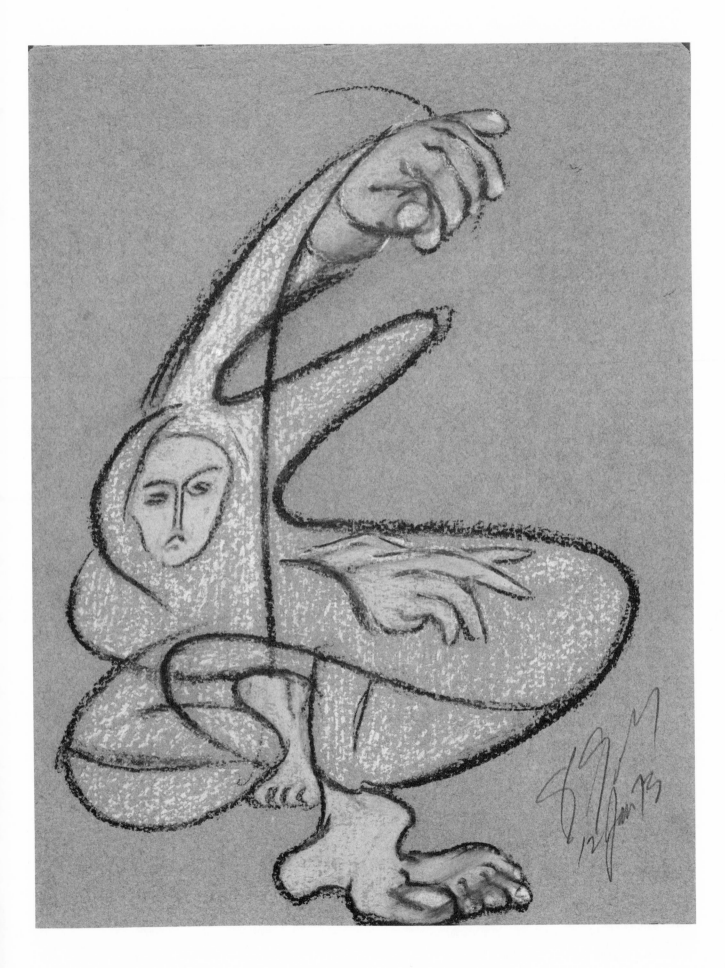

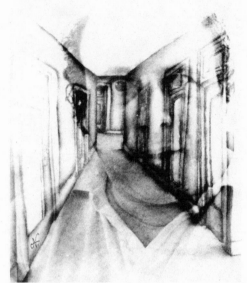

PhotoArt by Nona Hatay

"The way Gold works is very intuitive and spontaneous. He doesn't regard conventional ways."

Matthias Schossig
Art Dealer and Collector
Berlin, West Germany

Her posture is typical of every madonna's with head leaning to one side. Her mood is contemplative and introspective. The *Macro Madonna's* belly is pregnant with matter and form. She is the mother of space, the matrix of everything existing. Containing universe within universe, she reaches beyond the realm of the visible world. Light traverses her leaving trails like those seen in a Wilson Cloud Chamber. She is macrodimensional art in pure reductionist mode.

"Day after day one produces in the aesthetic range from abject failure to a slight cut above mediocrity, and once in a while, through a slip of the brush and an accidental splash of paint, something really quite extraordinary. This only happens a handful of times in an artist's career."

—E.J. Gold

MACRO MADONNA (F.P.)
Pastel on Sennelier, 1966.
Lithograph on Arches paper.

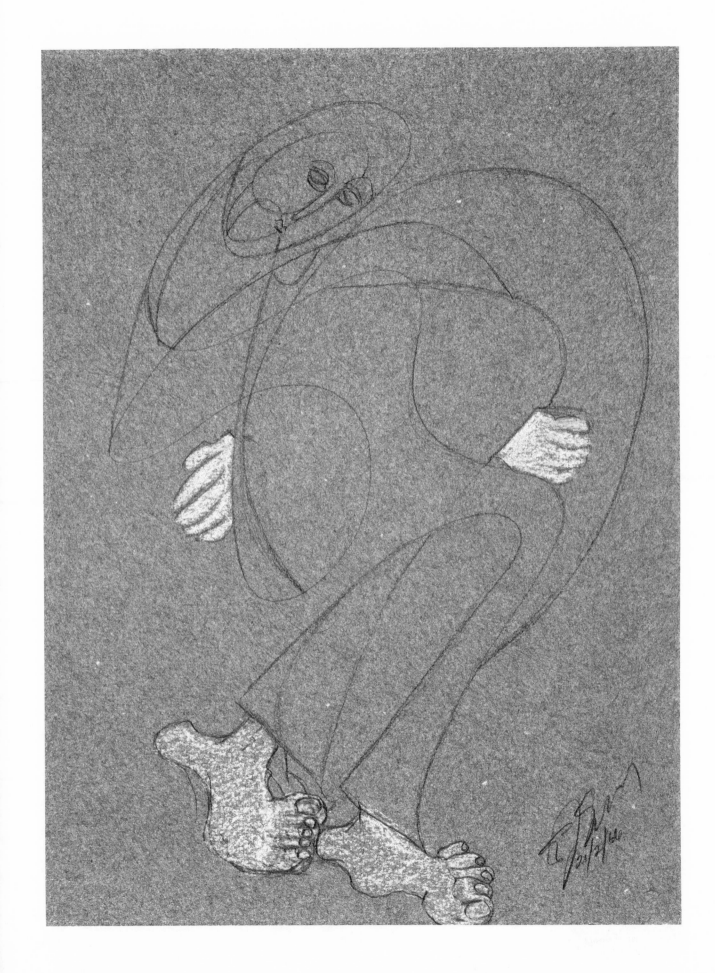

The tense play of balance and counterbalance contributes to prop these precariously poised figures. Evanescence is their mood. Here the artist seems to be toying with an implosion of energy and stretching the laws with which we customarily limit ourselves and our perceptions.

What comes to mind once again is a reference to higher more subtle bodies contained within the biological and electrical sphere, barely held in place by the heavier matter of visible bodies. A lack of familiarity with the form, substance and nature of these finer materials impedes our ability to know what we are looking at... perhaps the essences of beings like ourselves.

"E.J. Gold's intellect, passion and intensity keep him on the cutting edge of the art world. He is a contemporary Renaissance man, a genuine avant-garde visionary whose artistic expression will stand the test of time. We are all enriched and expanded by E.J. and his work."

Larry Rosenbaum,
Past Pres. Board of Advisors
Nassau County Fine Art Museum
Gallery Director, New York

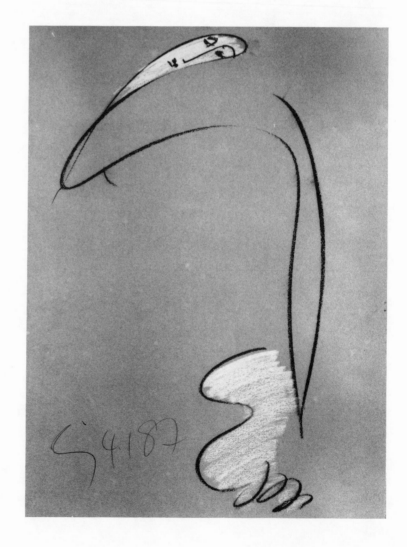

SWEEP SECOND HAND
Pastel on Sennelier, 1987.

ONLY PART OF THE DRAGON (F.P.)
Pastel on Sennelier, 1987.

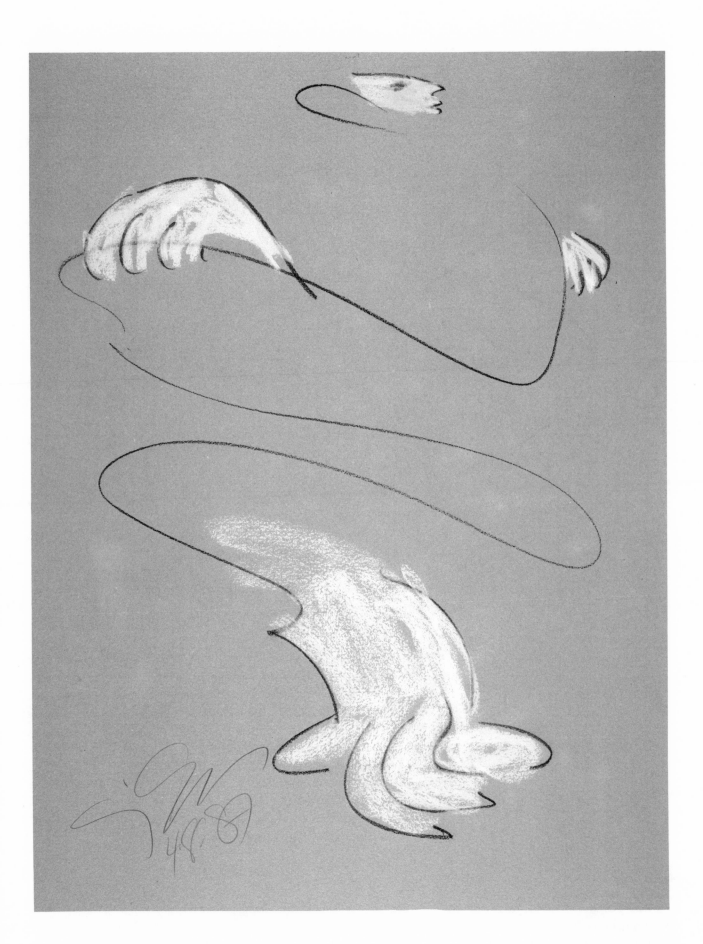

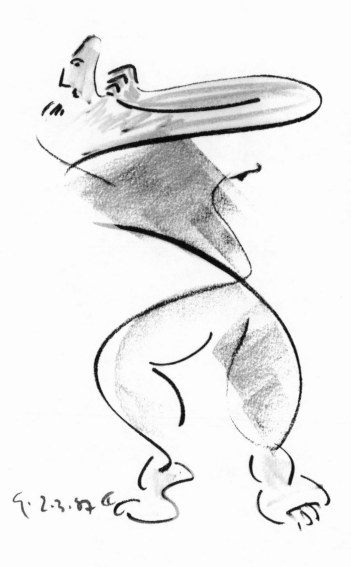

"E.J. Gold is a man before his time."
Janet Green, Art Collector

Transparent Energy Fields

Suggesting and translating movement is only to be expected in the realm of gesture. In this series the artist has laid down wide, fluid strokes which sweep across the figures and stretch them horizontally. The surfaces have been lightly colored but there is no mass to them. The controlled lines capture these sprightly characters who leap off the page in their curvaceous frolics.

Transparency adds to their otherworldliness. The figures disintegrate before our eyes while airiness and extravagance combine to cajole the eye of the viewer into the perception of an expanded reality.

RIDING UP TOP
Pastel on Arches paper, 1987.
Marilyn Charles Collection.

FREE FORM FIGURE (F.P.)
Pastel on Arches paper, 1987.
Glenn and Lee Perry Collection.

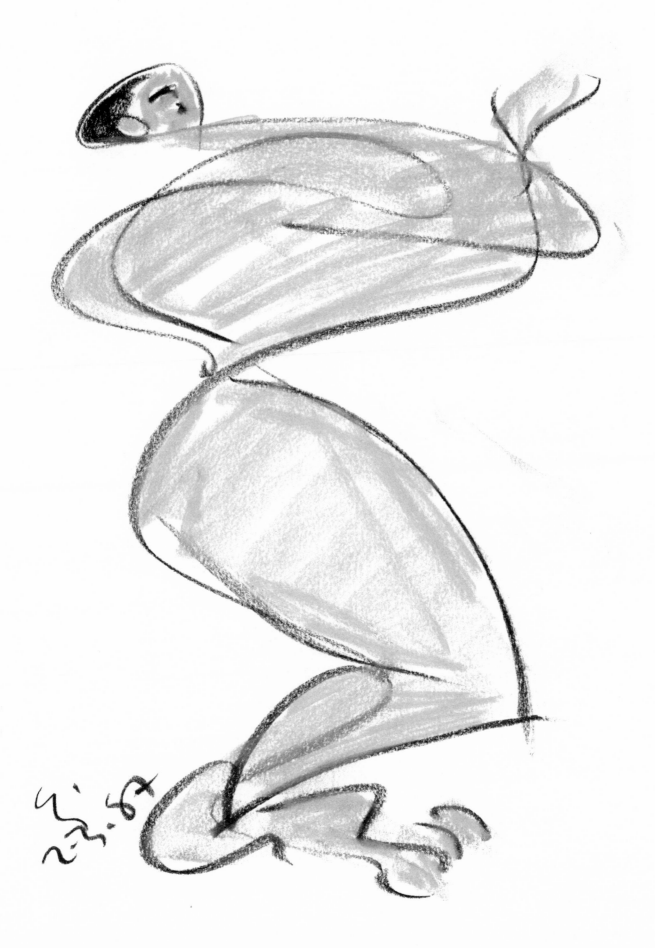

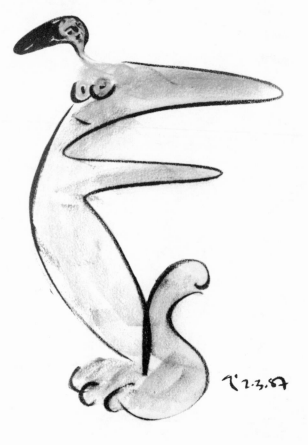

Working with so few lines confronts the artist more often than usual with the dilemma of knowing when to stop, of recognizing the completion point of a drawing. The danger of going too far is always lurking in the background ready to destroy any piece dependent upon exactitude in spontaneity.

With wonderful whimsy Gold invites us on a grand tour of finer, more rarefied atmospheres where svelte creatures such as these perambulate cheerfully, or gracefully glide along. If ever you've danced the samba or any hot latin dance you know that these dancers are really in the swing of things.

In both of these drawings, the disproportion between the bodies and the feet adds an element of incongruity to these ethereal silhouettes. But more importantly, the hand of the artist is sure and free, leading the drawing in the direction of a disintegration of its component parts.

"Although he was influenced by Cezanne and Matisse, Goya and Rembrandt, and has drawn freely upon their discoveries, ultimately, it was Rico Lebrun who provided Gold with one of his most important technical keys by showing him that classical painting was produced in light and dark through the underpainting, and then colored with thin pigmented glaze.

"Rico Lebrun provided Gold with a philosophical base from which to begin. His work was monumental in scope and scale. He had a passion for Goya and a profound desire to paint the inside of a cathedral. The passion for Goya Gold kept, the grand scale also, but the desire to paint the inside of a cathedral never caught fire with him."

—Joyce Kenyon, Gallery Director

SAMBA DANCER
Pastel on Arches paper, 1987.
Joyce Kenyon Collection.

OH FEET DON'T FAIL ME NOW (F.P.)
Pastel on Arches paper, 1987.

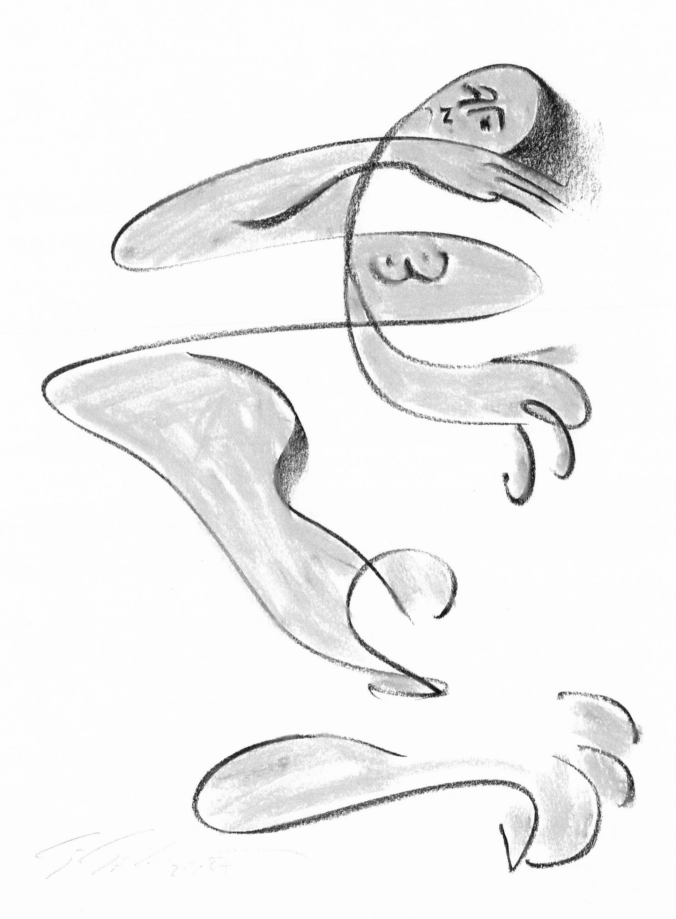

"Gold has made his reputation by pursuing the supra-ordinary through innovative and contro-versial experimentation."

Per Heiberg
Art Consultant and Collector
Oslo, Norway

Gold's antidote to perceptual limits and habits is to transgress clichés of modernism, surrealism, expressionism, and what Gold describes as annoyingly persisting figurative conventions dating back to the worst, most patron-controlled pedestrian landscapes and portraits of the Renaissance. He offers alternative perceptual modes by creating distortions and leaving gaps in the image, thus gently encouraging the development of new categories of perception. In stretching the limits of our perceptual apparatus, reduction to the visual abstract often meets reduction to the aesthetic abstract halfway.

In the abstract experiment on this page, solid areas are reduced to a minimum, lines flow freely in eloquently dynamic, sweeping—yet concise—gestures. It has been left open, unhindered, unbound and unfettered—a swirl of energy, a self-contained spinning matrix of particles.

Sometimes it seems as if Gold had glimpsed something so fleeting that his drawing could only catch its momentary afterimage. Like many of his predecessors in modern art, Miró and Picasso in particular, Gold claims that he paints only what he sees, exactly as he sees it.

Economy of line and certainty of gesture speak for the discipline exercized in this art form. A few strokes are more than sufficient to indicate a posture and an attitude. To create the illusion of movement on the opposite page, the artist has produced a counterbalancing isometric effect of opposing lines which indicate stress and tension. One can fully sense the energy holding back, ready to pounce at the sound of the whistle.

SPINNING TOP
Pastel on Sennelier, 1987.
Bruscilla and Barry Campbell Collection.

SPRINT RUNNER (F.P.)
Pastel on Arches paper, 1987.

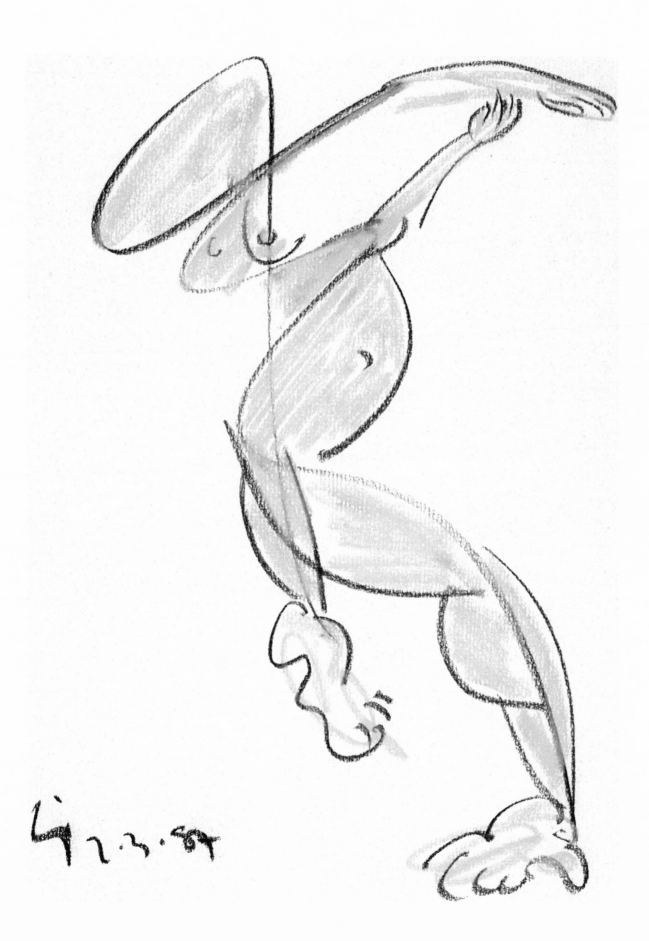

"I don't produce art to sell art. It's not my intention, nor my purpose."

E.J. Gold

Photo Credit: Mariette Fournier

Ladies with a Special Curve

Art as experimentation is by nature scientific and systematic. In this sense, the artist as experimenter engages himself along a path with a thoroughness comparable to any scientist's, enabling him to fully explore and draw on what is contained in a visual motif.

In the same way that a scientist repeats again and again a test in order to establish its parameters, measure and verify its results, so the artist works with a visual element repeatedly in order to discover its parameters, observe its behavior, and establish aesthetic principles. Visual elements are explored to see what happens with them under a variety of conditions.

This series of marvelous blonde-hair ladies produced in a single day, at a single sitting, provides us with the opportunity to observe how graphic elements can be maintained, transformed, amplified, and eventually, when all their possibilities have been exhausted, discarded.

Beginning with *Taking It All In Stride,* we will identify the trajectory of certain graphic elements. The basic motif is a strong curve to the right indicating and outlining the body, counterbalanced by an undefined protrusion to the left. The arms are non-existent. The head is covered with flowing blonde hair. The breasts have been pushed over to the right side in two curvaceous shapes. The feet are in full movement.

TAKING IT ALL IN STRIDE (F.P.)
Pastel on Sennelier, 1987.

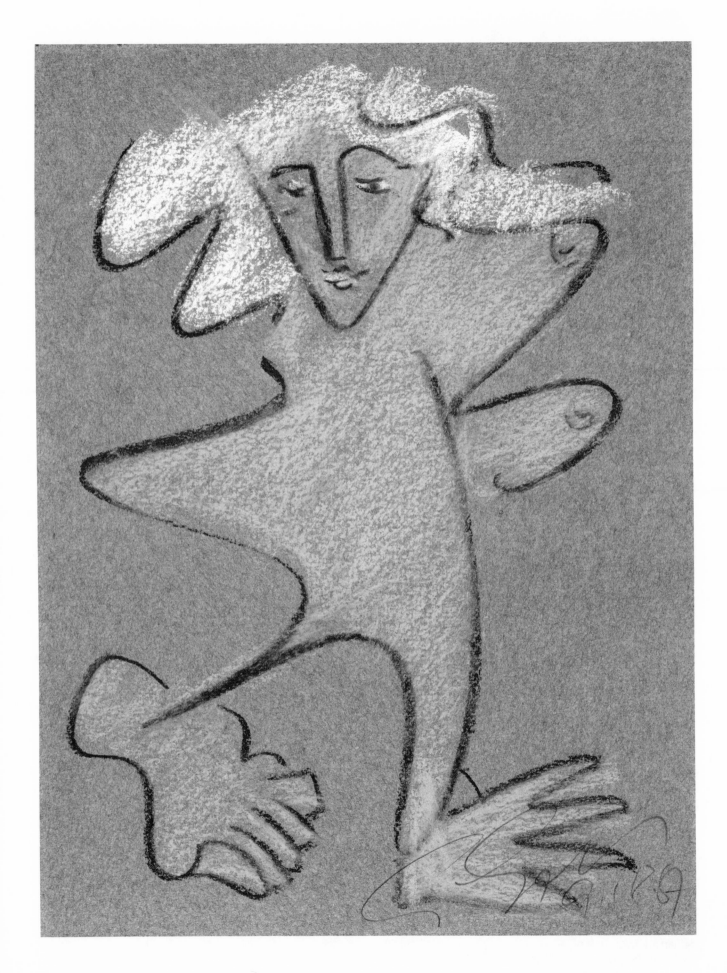

"In the course of a painting many things can go wrong as I seek solutions. Sometimes the solution creates new problems. Everything on the canvas readjusts. If I make one change here, then I must make that change in juxtaposition there to restore relative harmony. A painting has necessity for internal logic and relative balance, yet does not necessarily reflect the harmony and balance existing outside its own domain. I speak of domain in the topological sense."

E.J. Gold

Although the matter the artist works with and the manner in which he works is different from that of the natural scientist, the *process* in which he is engaged is quite similar. The artist as scientist seeks to learn from this matter what the effect of variations is on it.

It's as if he enters into a tunnel which he cannot leave until the end. This explains the idea of working in series of images, of exhausting a motif. The gain is in the repetition and variation. That is also why the results are unimportant. What counts is the experiment itself. That is why Gold so often emphasizes that the finished product is a dead thing, the remains of a process that is intensely personal, subjective and incommunicable. This is so true that from the outside it is difficult to say which piece in a series is most successful. By whose standards?

In the same breath as the preceding image *Beyond All Reason* maintains curvature of body, flowing blonde hair, running feet, and a protruding element to one side which, in this case, has more definition and can be recognized as arms ending with fingers.

The gesture creates a sweeping movement balanced by a composition that is open and yet tight. One can sense a condensation of energy waiting to burst forth or leap off the page.

PhotoArt by Nona Hatay

BEYOND ALL REASON (F.P.)
Pastel on Sennelier, 1987.

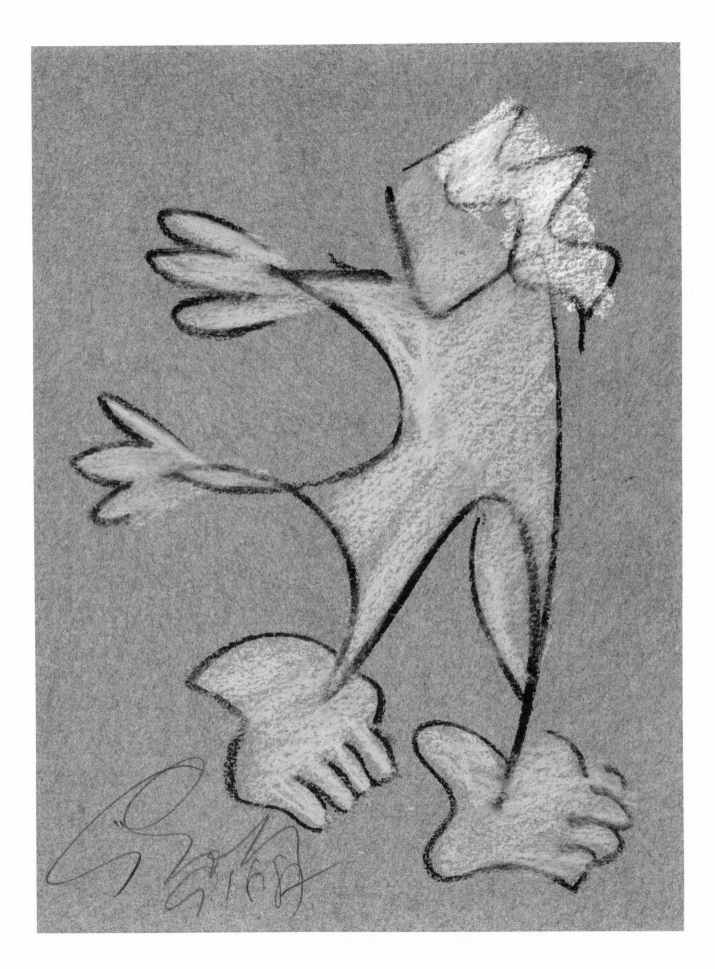

PhotoArt by Nona Hatay

"The images strike at gut level, hinting that, just out of perceptual range, there is something we could and should be knowing; reminding us that there is more in our voyage from birth to death than ordinarily forces itself upon our awareness."

Sydnie Kunin
Amherst Art Associates
Amherst, Massachusetts

All the visual elements are amplified. The leaning posture is slightly more rounded, the feet captured in their movement forward are more springy, the blonde hair is more flowing, the uplifted arms are more theatrical.

The introduction of these morphological amplifications happens in increments and degrees. As the original motif expands, the figures come to life in unexpected ways. Minute adjustments of the defining graphic characteristics contribute to systematically create a different mood and feeling.

These subtle mood modifications shift our own reality perceptions by confronting us with transitory forms, intermediate realms, shifting platforms on which to stand.

Meanwhile the artist has invented a marvelous notation system for dance. And so with grace and ease, his dancer adopts a beautifully choreographed posture.

"A work of art shouldn't be sold as a piece of living art, it should only be sold as a corpse. The corpse is what you see in galleries. It's all that anyone can ever know past the moment of the creation of the art work. Only corpses can be bought and sold and traded."
 —E.J. Gold

PERSONA DRAMATIS (F.P.)
Pastel on Sennelier, 1987.

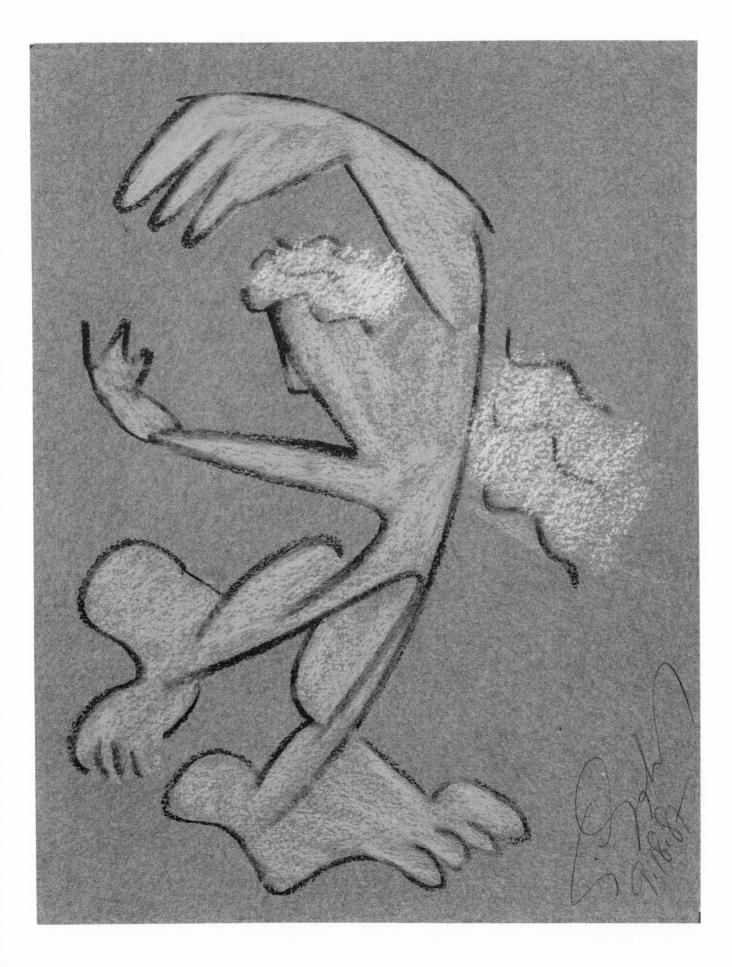

At the end of the experiment abstraction finally takes over the sequence, and yet, with the little amount of associative detail available to it, the eye still discerns a figure by completing the missing information and filling in the gaps.

In effect the hair is still present, as well as the curved profile, the jagged protrusion to the left, and the running feet. But the overall character is quite distant from the original.

In the image below, several new developments have been introduced profoundly altering the basic form. The flowing blonde hair and the curved protrusion to the right are merely vestigial. The body has become more angular and the mood is more dynamic than ever.

"I don't care how pretty I might make my drawings. I'm not looking to make pleasing forms. I often begin to look for some shock value on top of that."

E.J. Gold

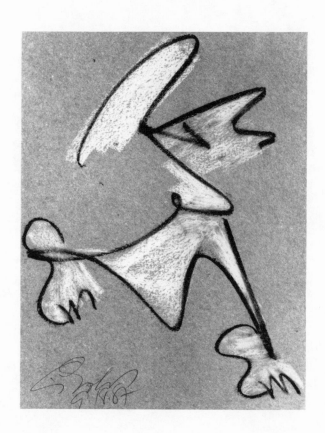

FLAMBOYANT FLAMENCO
Pastel on Sennelier, 1987.

IN AN UNBELIEVABLE HURRY (F.P.)
Pastel on Sennelier, 1987.

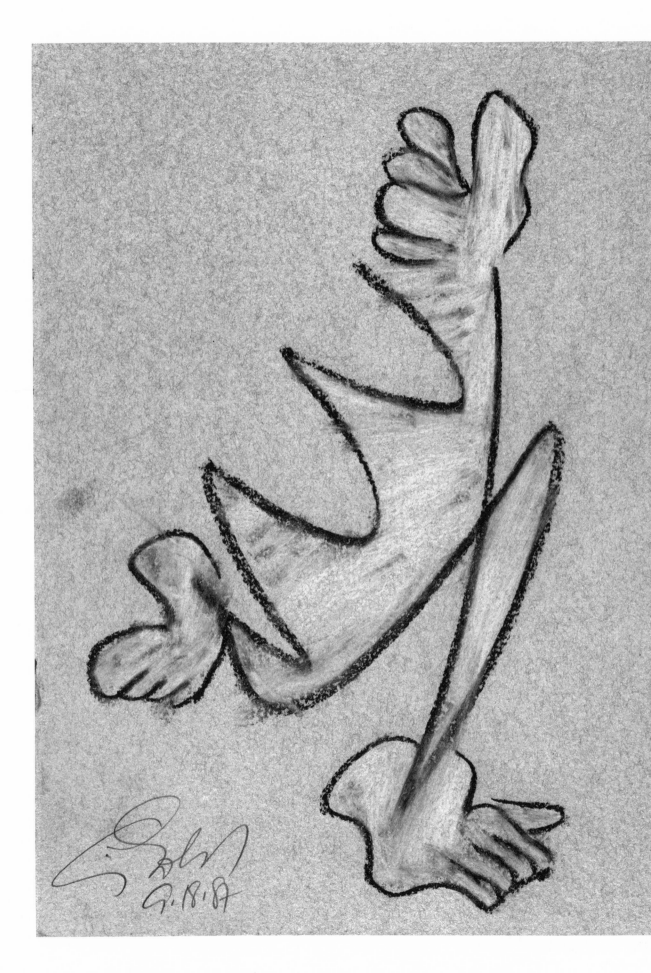

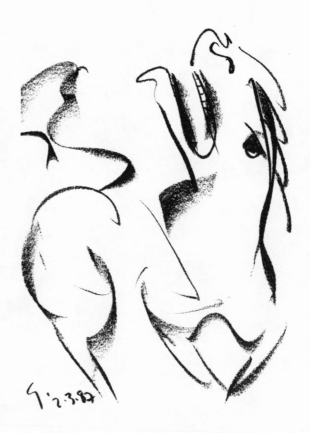

"We voyage in a labyrinth, a macrodimensional maze of living electrical force, cloaked by a thick layer of ordinary life. The most serious obstacle is the uncontrollable urge to convert everything to the familiar, to reduce it all to the level of the primate brain."

E.J. Gold

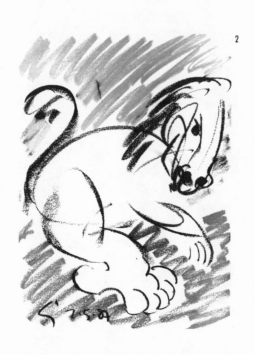

Whimsical Beasts

Gold has created few animal drawings. These tend to be renditions of fantastic dragons, sea serpents, friendly monsters, and beautiful horses.

This dynamic series of images has vibrancy, power and inspiration. On the one hand it is evocative of the pure unbridled energy of wild beasts, and on the other hand it conjures up mythical associations which spring forth in our own imagination.

Even though it is only hinted at by a few lines, the horse on the opposite page is almost alive with its face angry and menacing, and its teeth bared and determined. In sharp contrast to this, the image to the left reveals a playfully youthful quality: running in the fields, jumping and standing on hind legs as a spirited and unbroken horse would do.

In *Horse of the Apocalypse* Gold has captured the darker side of "horseness." The beast appears powerful and threatening, evoking a mood of awe. This macro-dimensional horse is not part of this world, it merely visits at the last hour.

HORSE OF THE APOCALYPSE (1)
Pastel on Arches, 1987.

A SUDDEN CHANGE IN DIRECTION (2)
Pastel on Arches, 1987.

STUDY FOR EQUESTRIAN STATUE (F.P.)
Pastel on Arches, 1987.

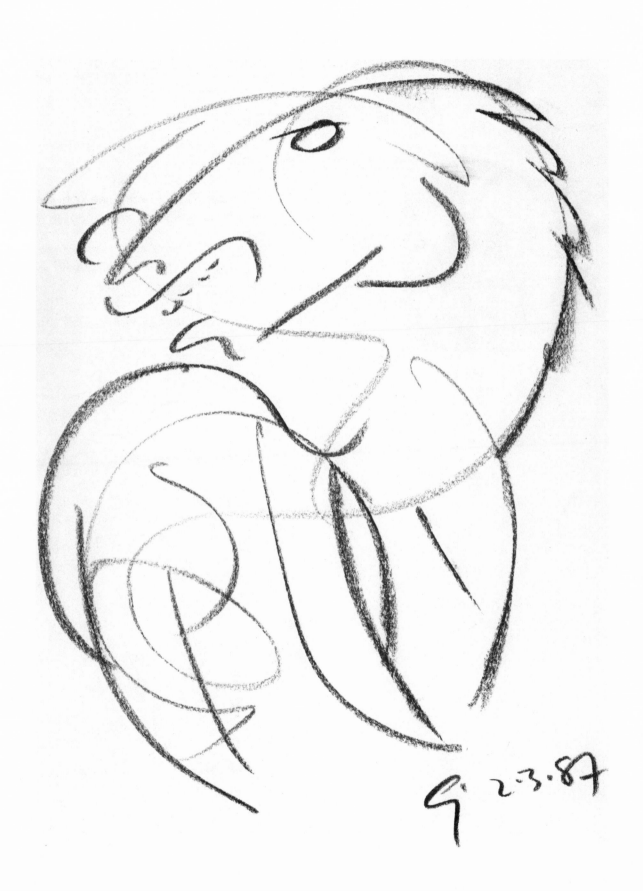

G 2·3·87

PhotoArt by Nona Hatay

Of course it takes Gold to combine a horse and a chicken into one neat package! But we cannot understand why he didn't call it a chorse or a hicken or a horcken or a chirse.

The amusing *Dancing Dragon* owes something to Walt Disney's fabulous *Fantasia* where we see hippopotamuses dancing with alligators. It also has the good-natured quality of the *Reluctant Dragon* and is thoroughly lovable.

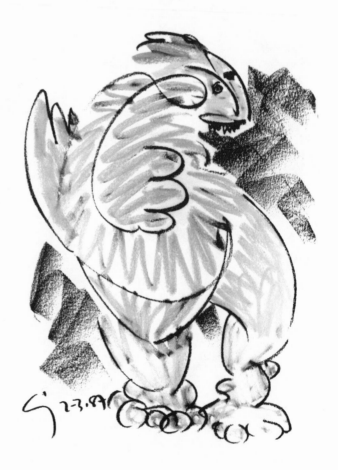

THE BIGGEST CHICKEN
Pastel on Arches, 1987.

DANCING DRAGON (F.P.)
Pastel on Arches, 1987.

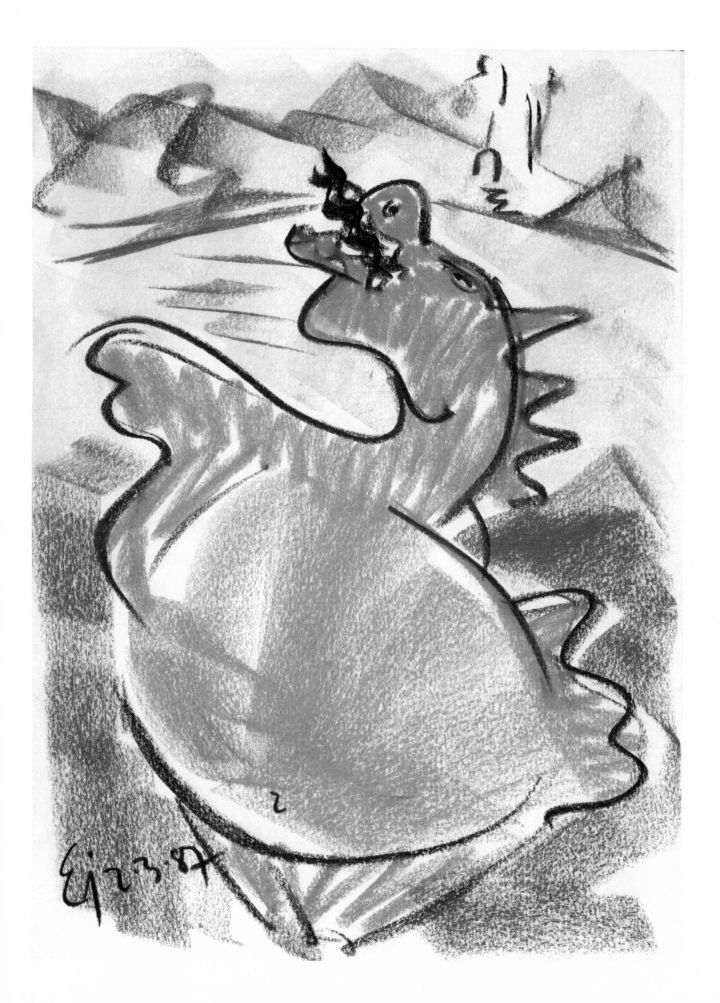

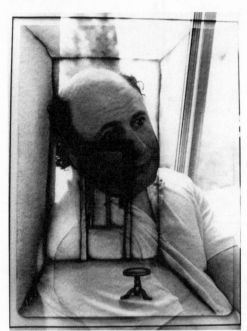

PhotoArt by Nona Hatay

Svelte Musicians

This series of images is an experiment in synesthesia, deliberate or not. For some uncanny reason the visuals succeed in stimulating auditory sensations. Is it because the figures are suggestive in a particular way? Do the lines reproduce sound waves that are perceived on a subliminal level? Are the postures the principal keys to unravelling this conundrum?

It's not surprising that Gold has portrayed musicians with such verve. He himself has played music and appreciated it since childhood. While living in New York, he managed a jazz club and sat in on bass with many jazz luminaries. More recently he has composed and recorded experimental music in idioms ranging from cool jazz to symphonic.

As a series these images rely on simplicity and economy of stroke to suggest dynamic movement, musical notes, and piercing sound. The broad gestures evoke postures which are for us one of the principal keys to interpreting these images.

The *Master of Ceremonies* on the opposite page is an exercise in restraint and succinctness. The treatment is bold and exclamatory. This highly stylized rendition captures the high brow manner of many individuals groomed by the stage and the position of being in the limelight. It relies on exaggeration of detail to express a mood of haughtiness, theatricality, and superiority in the character.

"Gold is an ideal subject for an expanded study using a variety of experimental techniques because he himself is an artist who thrives on experimentation and unorthodox methods in regard to his art. He is an accomplished musician and actor, as well as an innovative artist working in various media including painting, drawing and sculpture."

Nona Hatay

THE MASTER OF CEREMONIES (F.P.)
Pastel on Arches paper, 1987.

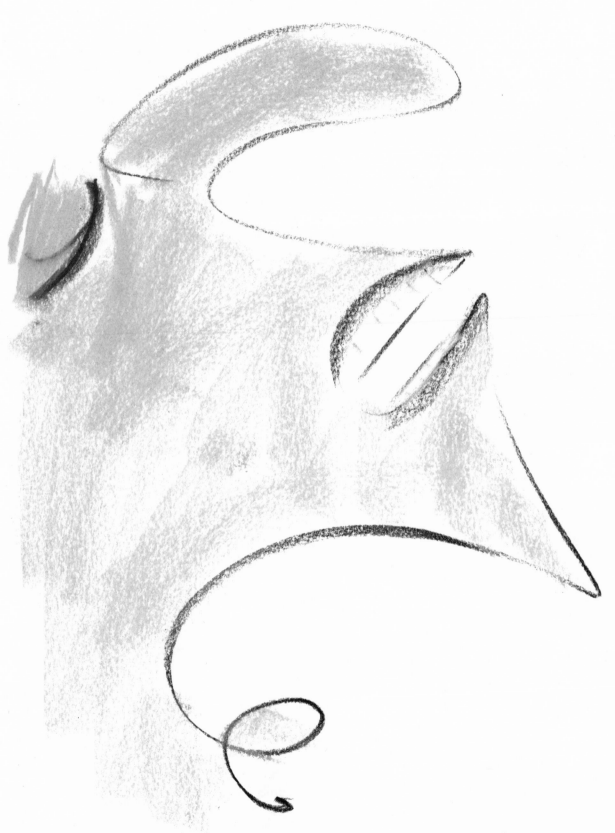

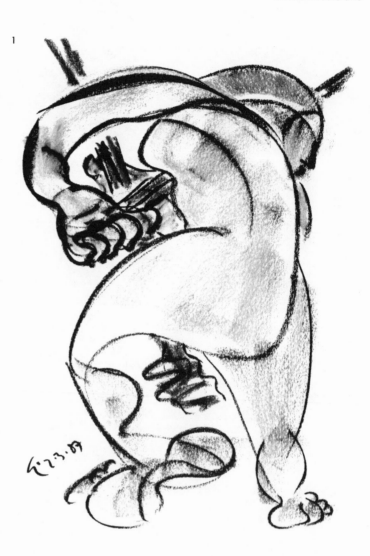

"Never ascribe to yourself the idea that you are producing. You are simply a tool in the hands of something so powerful that you have no concept of what it really is."

Tanaka

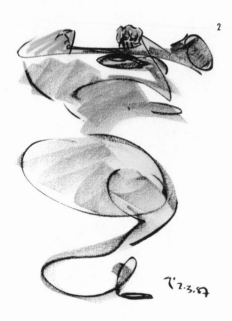

A strong juxtaposition of a flurry of abstract lines with a deliberately representational violin creates contrast and dimension in the drawing on the opposite page. The energy that goes into playing the instrument is evoked in this subtle *tour de force*.

The image at the left is another example of an original natural form abstracted into a transitional form barely held in place by significance superimposed upon it. It uses a minimal number of lines to maximize a suggestion by tuning into the emotional explicitness of music, in this case, Dixieland music.

The image above is a provocative departure in whimsy where the artist combines his theme of mythical beasts with that of the musician, blending them into one and creating an ambivalent drawing with ominous overtones reminiscent of traditional tales of the devil as beast seducing villagers away by walking through their towns playing a fiddle.

**MUSIC HATH CHARMS
TO SOOTHE THE SAVAGE BEAST** (1)
Pastel on Arches paper, 1987.

DIXIELAND (2)
Pastel on Arches paper, 1987.

THE MAD VIOLINIST (F.P.)
Pastel on Arches paper, 1987.
Connell Foundation Collection.

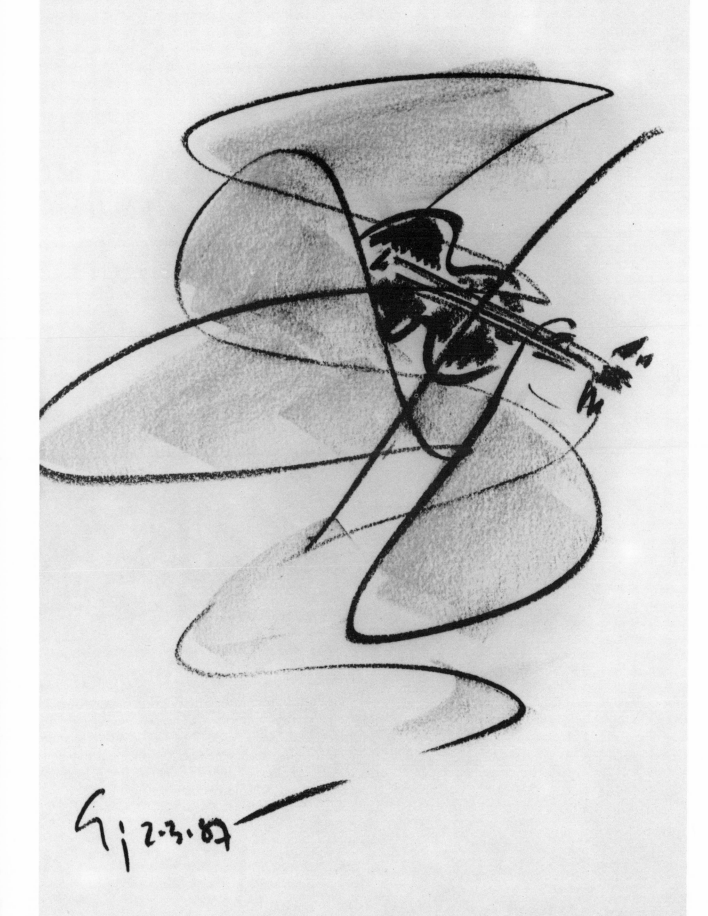

"One of the great things in E.J. Gold's sculptures and drawings is that they are abstract in form, but, in substance, incomparably more real than most of the things we see in our everyday life. They really succeed in creating a mood that is material and fills the observer like the wine of music in the cup of silence.

—Giampiero Cara, Journalist
Esoterica Magazine
Rome, Italy

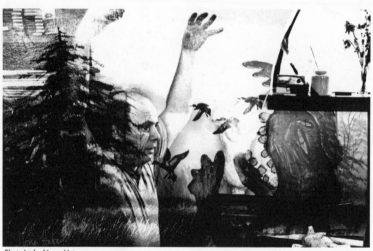

PhotoArt by Nona Hatay

This image on the opposite page incontrovertibly answers objections about superfluous lines and demonstrates that not only do they not interfere with the emerging form but actually contribute to define the emotional quality of the work. This is a good example of energy waves bound and contained.

THE OPENING ACT
Pastel on Arches paper, 1987.

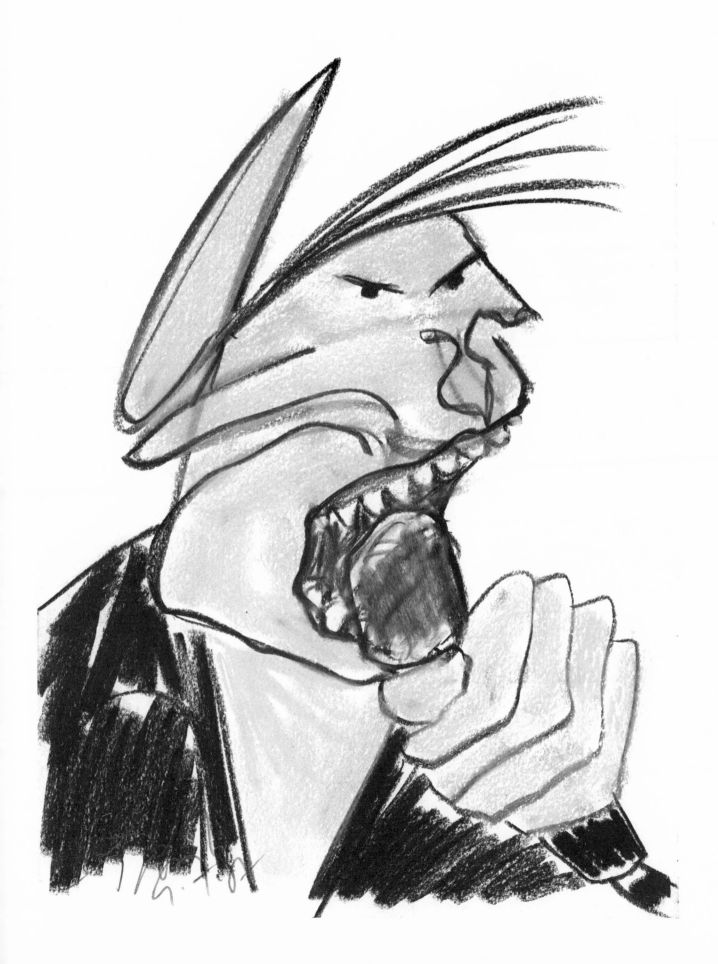

Photo Credit: Mariette Fournier

"Gold is tireless in his dedication to his work, and never seems to run out of inventive and original means for artistic expression. He approaches his work with intensity and conveys a sense of power and dynamism in all that he does."

Mark Connell
Connell Foundation

T his superbly elegant rendition invites us to take festively to the floor in a foot stomping square dance or jig! It relies on a minimal number of associations to steer the viewer in the direction of a new perceptual reality structure.

"Part of my thesis revolved around the idea that until clear glass was available to protect works on paper, and until the technology of paper conservation came along, paper art was considered second-rate. In addition to that, the aristocracy typically were the buyers of art; they had big homes, and they wanted big pieces. Big pieces don't lend themselves to paper as a receiving device. Canvas stretches big. You can get canvases and tapestries big enough to accommodate even the largest castle.

"Until relatively recently, even music was unavailable to the masses. It was only available to the aristocracy, then at certain times and in certain places, to the rest of the population. Many people never heard music outside the home. In many homes they would have instruments or they would sing, simply because there was no music available to them. There were no records, no radios, no television, no books. Even books were not available to the masses for quite some time."

—E.J. Gold

BLUE FIDDLER ON THE FLOOR
Pastel on Arches paper, 1987.

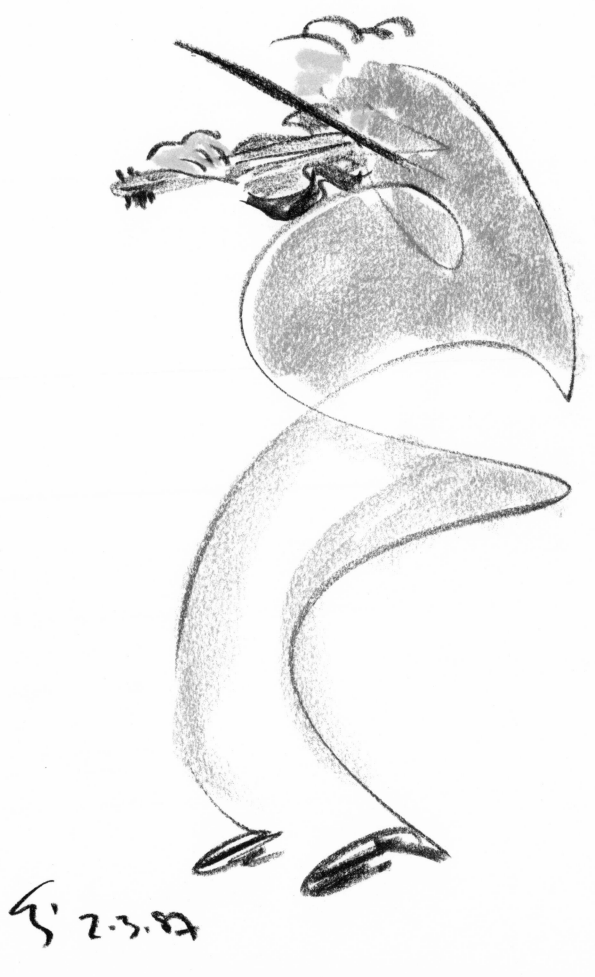

PhotoArt by Nona Hatay

Frenetic exploration and experimentation characterize Gold's most casual endeavors. This is reflected in the sheer quantity of completed images he has created since getting back into full production mode in 1986. His subjects have been distilled to a relatively small set of themes which he approaches again and again separately or in combination, from different points of view, and in a variety of media.

Classical in its preoccupation with figures, albeit not particularly human, surrealistic in its lack of regard for representational accuracy, Gold's style conveys a hypnotic lyricism populated by the fluid creatures he conjures.

Bop Bird stands out among the best of his sinuous contributions to form and texture. A few deft strokes are all it takes to establish a resonance between the swing and rhythm of the music alluded to and the image created.

The *Bass Player* blurs the distinction between abstraction and realism, and provides a good example of how reductionism works with perception allowing the viewer freedom from overdefined form.

"The amazing thing about E.J. Gold is that he is able in just a few lines—like Picasso and other great artists—to capture his subject matter. He is incredibly multi-talented and has unlimited imagination and originality. But more importantly, he takes chances and tries new things."

—Jill Scopazzi,
Antiquarian Book Dealer,
San Francisco, CA

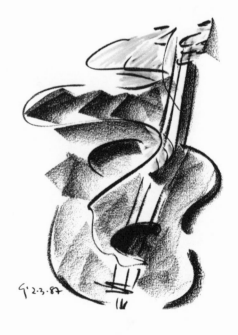

BASS PLAYER
Pastel on Arches paper, 1987.

BOP BIRD (F.P.)
Pastel on Arches paper, 1987.

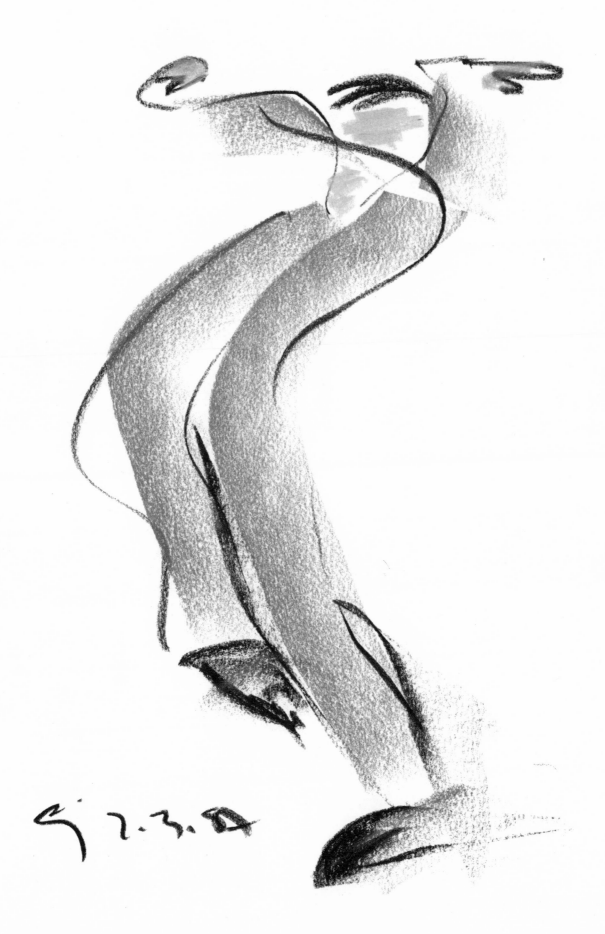

"E.J. Gold is very interesting and spontaneous. If he feels like painting he goes into his painting studio and paints. If he feels like recording music, he goes into his recording studio and does music. He goes from medium to medium, from art to music depending on what he feels like working on. His studio and house are set up so he can do art or music at any time. I find that very stimulating and inspiring."

Nona Hatay

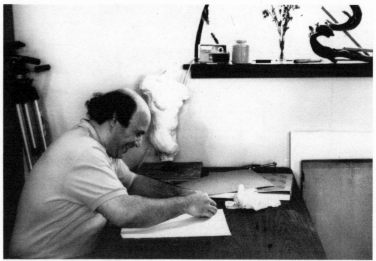

PhotoArt by Nona Hatay

The *Horn Player* is a veritable tribute to musicians. It shows the tension between spontaneous gesture and deliberate figuration which mirrors a tension between sight and sound. *Seeing* the horn player is *hearing* him.

Gold is an accomplished draftsman who chooses to depart from traditional figurative drawings in order to gain efficiency in his renderings of archetypes, here the archetype of a musician. The strength of this experiment lies in its power of evocation.

Economy of gesture has made this one of the most successful in the genre. Restraint and control contribute to its understated quality, while rhythm and explosiveness are perhaps what imitate the sound of the horn.

THE HORN PLAYER AT THE BLUE NOTE (F.P.)
Pastel on Arches paper, 1987.
Serigraph on Arches paper

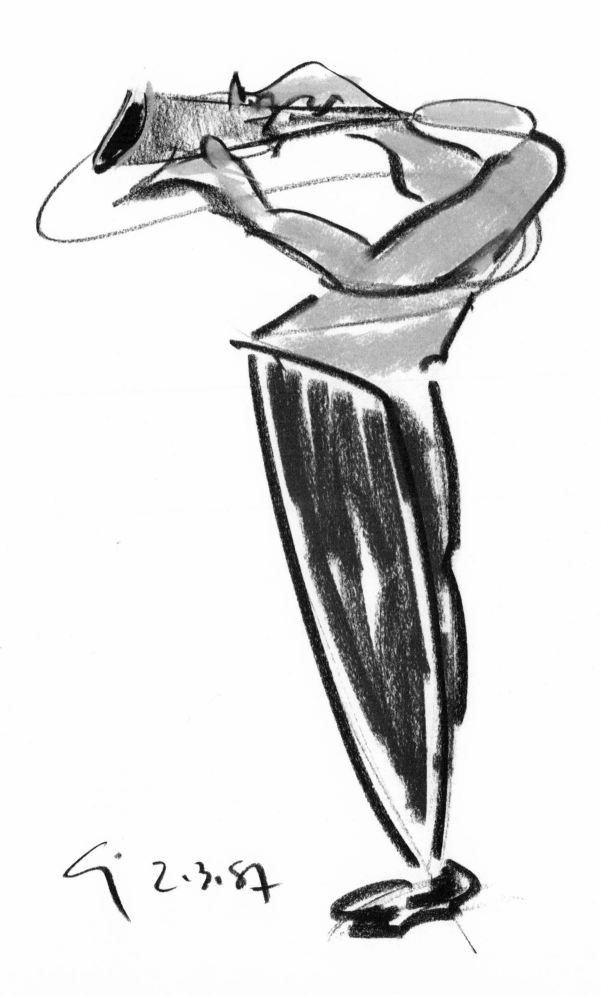

Kickers and Jumpers

This mirthful series has a playful quality to it that proves without a doubt that Gold delights in creating enjoyment and mirth for the delectation of the spectator. The figures bounce off the pages, leap into thin air and barely touch the ground before leaping off again. The experience of excitement and elation at their discovery give these a very special place among his gesture work. Many of them make you feel lighter just by looking at them, but the artist does not propose that they be used as diet substitutes....

The zest of these images ranks among the most upbeat. One can only gasp at the sheer fun-loving mood suggested. This one in particular is an excuse for the artist to express with the greatest of ease the flamboyant style of a vigorous dancer.

"E.J. Gold is an artist who combines representational values with modernist humor and vitality."

Peter Kraus
Ursus Rare and Scholarly Books
New York

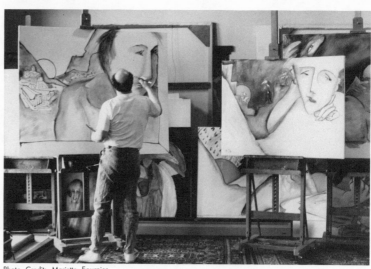

Photo Credit: Mariette Fournier

KICK UP YOUR HEELS...AND YOUR TOES (F.P.)
Pastel on Arches paper, 1987.

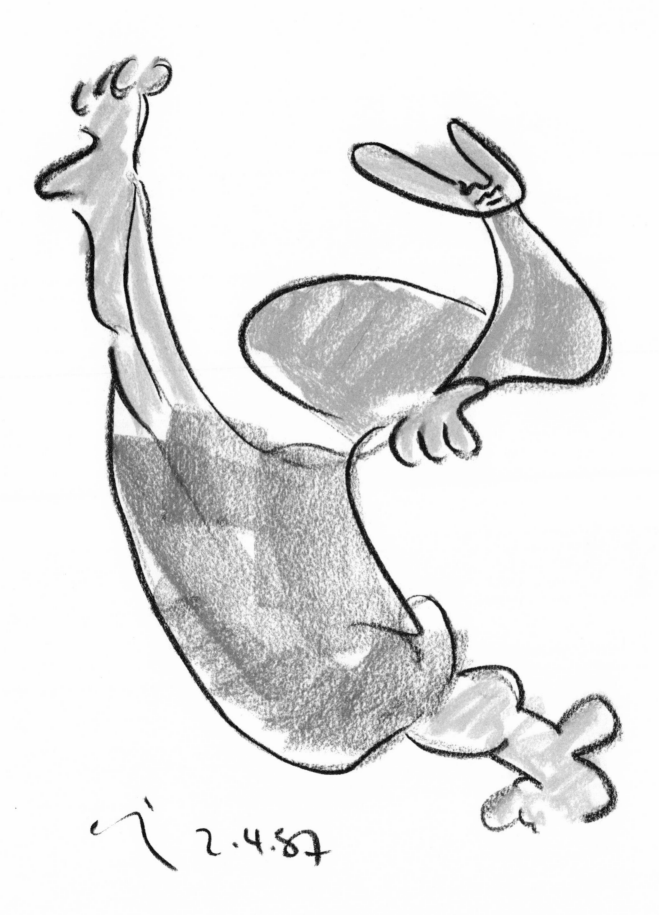

2.4.87

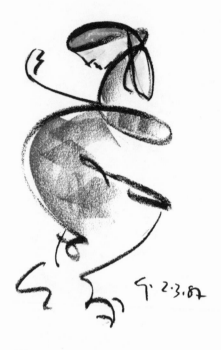

Anyone who has ever met E.J. Gold knows that he is a natural raconteur as well as a proficient writer. This ability seems to carry over into the visual realm lending a story-like quality to many of his images which read like vignettes and thrive on anecdote.

Whether intended or not, the narrative aspect of this work is an effective hook which draws the viewer into participation. By trying to interpret you get involved with the contents. Penetration engages you in a process of uncovering the associations supporting an image and activates a certain sense of wonder because there is always something more that seems to elude the eye.

The *Folk Dancer* overflows with movement and expression. His wide pantaloons convey power and strength, dazzling physical prowess and graceful ease.

"Gold captures on paper the essence of bodily expression and posture which form our social masks—those we wear and those that wear us during our daily odysseys through the maze of social interaction. Each of these figures is representative of a very particular lineage of character type. Each therefore has his or her own individualized expression. At the same time, the economy of gesture and stroke gives each of these pieces a quality of universality."

Menlo Macfarlane
Artist and Choreographer
Grass Valley, CA

**SELF-EXAMINATION,
REVEALING NOTHING SERIOUSLY WRONG**
Pastel on Rives, 1987.

FOLK DANCER (F.P.)
Pastel on Arches paper, 1987.

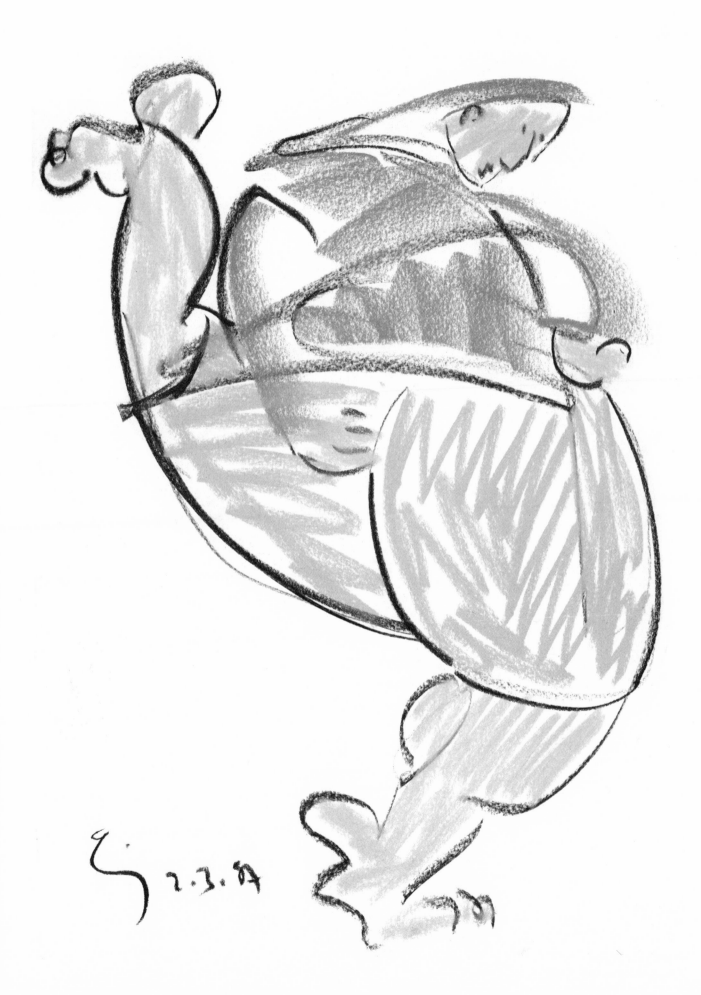

The true art of dancing is revealed to those who dare to dance in the rain as some performers—notably the great Gene Kelly—have already discovered long ago to our lasting pleasure. Perhaps this is a tribute....

The form here is particularly interesting in its deliberateness, while the transparency lends a debonair quality to this image.

"Every so often, nobody knows exactly why, it is possible to produce something which doesn't become a corpse, but which remains in the moment of creation. These are called masterpieces. Through a time warp, there's still a very power-ful connection between the thing and its original moment of crea-tion."

E.J. Gold

PhotoArt by Nona Hatay

"Creating black and white experimental multiprints is a very exciting form of expression allowing me to expand beyond the bounds of ordinary reality, to interweave images for a multidimensional or surrealistic effect. The juxtaposition of images in my multiprints seems ideally suited to reflect the many moods of E.J. Gold, as well as the many facets of his art.

"My work in the darkroom is always accompanied by the sounds of his original musical recordings. They provide a rich and textured background and contribute to my own interpretive compositions of the artist and his work....

"Each finished print is produced during total immersion in his atmosphere."

—Nona Hatay

DANCING IN THE RAIN (F.P.)
Pastel on Arches paper, 1987.

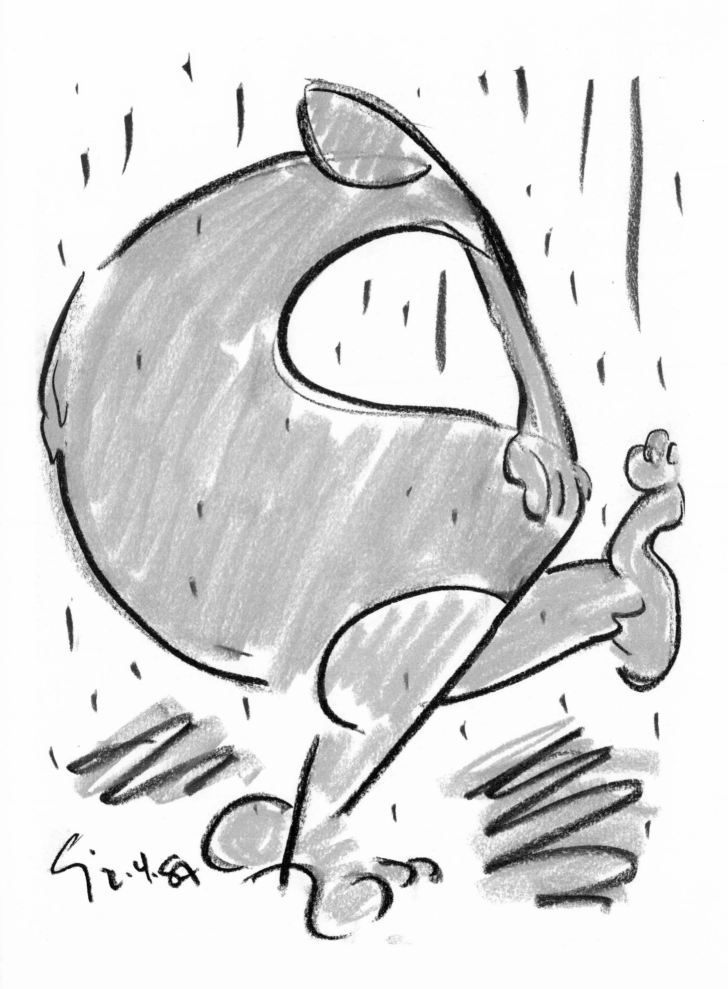

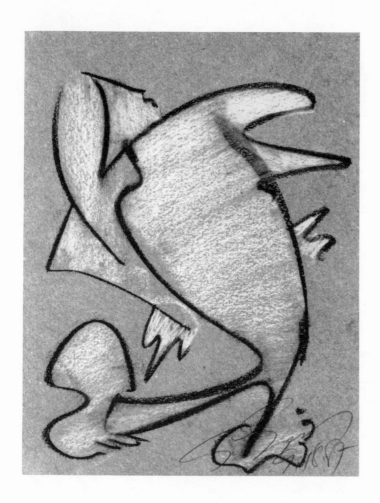

*"I use the human form as a
pretext or as a gateway."*

—E.J. Gold

One of the principal keys to understanding Gold's figuration is contained in the science of postures which reflect inner moods, and eternalized spaces, not to say mindsets. Posture conjures the archetype and elevates the portion of reality represented to a timeless space where it exists in itself as an ideal form, in the platonic sense.

The character on the opposite page is seductively charming, quintessentially Gold. Seemingly oblivious to the general effect of his passage, he trots along innocently, whistling a tune, head flung back, relaxed and carefree. He is ideally *Foot Loose and Fancy Free* and wins the prize for wit.

Economy of gesture has left no superfluous lines and the result is delightfully uplifting. One can't help but be transported to a wonderful space full of fresh air.

AND WHERE IS THE DOG?
Pastel on Sennelier, 1987.

FOOT LOOSE AND FANCY FREE (F.P.)
Pastel on Roma, 1977.

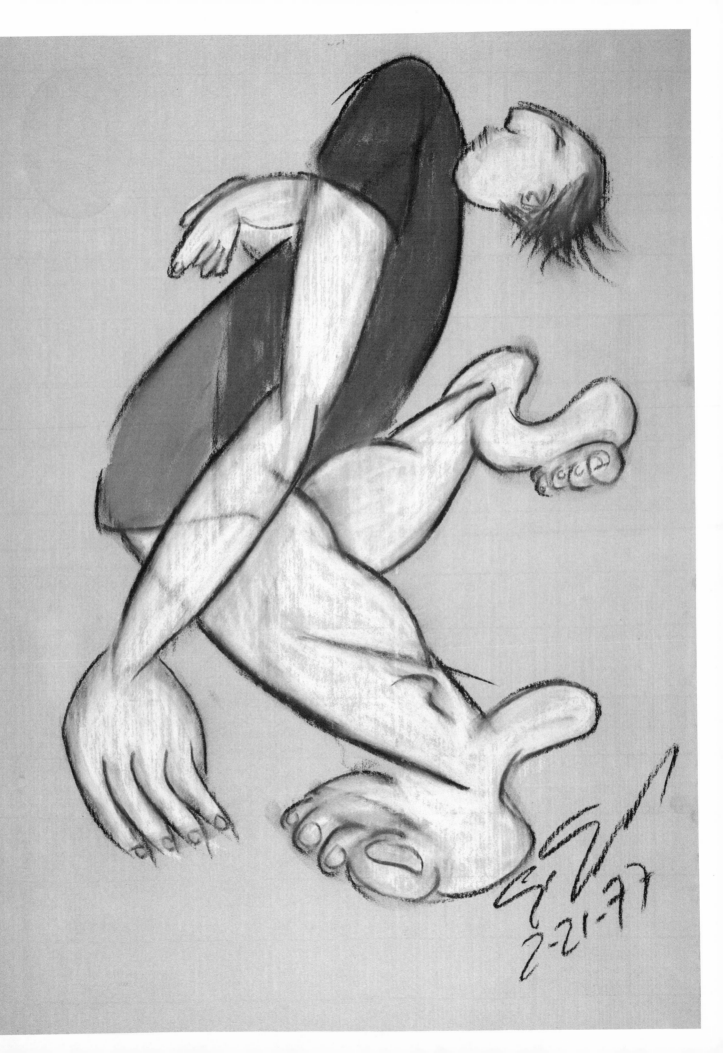

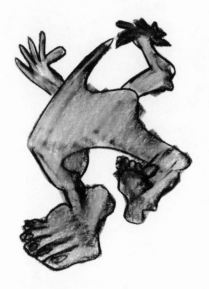

The Bigfoot and Bighand Family

"These drawings which appear whimsical and simplified at first glance are powerful mind-altering keys which allow the artist to re-adjust the overall reality-perception of the viewer."

Peter Heineman
Gallery Director and Architect
Denver, CO

Gold's early exposure to the work of Franz Kline and his enthusiastic sharing of ideas, often in the context of the Cedar Bar, infused him with the principles of isomagnification, the isolation and magnification of detail. Many of his larger paintings concentrate on this approach: the *Cosmo Street Corridors,* the *Scarf and Jacket* series, the *Neck and Shoulders* series, even some of his *Odalisques* reflect this tendency to isolate and magnify.

Isomagnification is probably carried to its furthest limits in the *Bigfoot and Bighand* series. But Gold does not limit himself to isomagnification. To this he adds his own characteristic morphological idiosyncrasies of style: distortions, exaggerations, and compressions, and his own inimitable sense of humor.

In his purely gestural work, the combination of isomagnification and morphological distortions act as keys to doorways that he has discovered how to unlock. That's why many of these apparently benign images have an underlying, almost untouchable, sinister quality.

Grospied is the quintessential "bigfoot" motif. By dwarfing the body to a narrow line it reduces the figure to two self-propelled oversize feet attached to a pivot point allowing it to pick up speed at will. Now this can be very funny to imagine, or it can be just a little too strange for comfort....

A SERIOUS GAME OF HANDBALL
Pastel on Arches paper, 1987.

GROSPIED (F.P.)
Pastel on Arches paper, 1987.

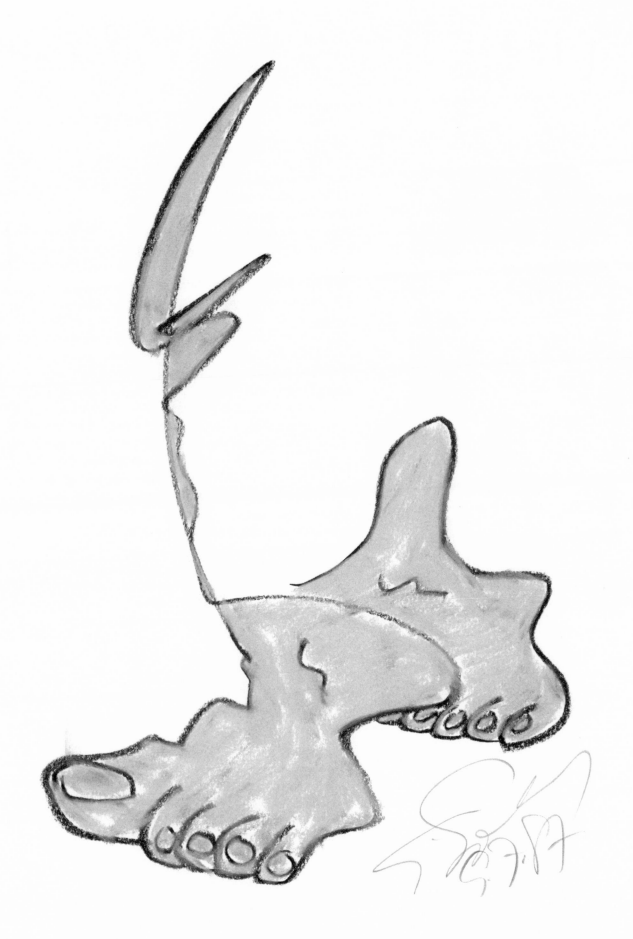

Photo Credit: Mariette Fournier

*"Gold is an experimental artist
interested in exploring boundaries."*

Jacek Muschol
Gallery Director
Vancouver, B.C., Canada

With a serious background in theoretical physics, including plasma research, and consultation with reputable think tanks, like the Rand Corporation, Gold developed some very compelling theories relating to the "time-space *discontinuum*." It is therefore not at all coincidental that his fundamental preoccupations with spatial problems are quite manifest in his paintings and drawings.

Working with isomagnification and unusual morphologies has allowed him to address problems relating to *scale, proportion, dimensionality* and *fuzzy boundaries* that have never been addressed before.

In fact not since the beginning of this century have macrodimensional preoccupations been so central to an artist's quest. The major retrospective entitled *The Spiritual in Art* sponsored several years ago by the Los Angeles County Museum of Art which travelled to several North American cities, illustrated the metaphysical underpinnings of the origin of modern art. But the spiritual in art has not been very popular since, perhaps with the exception of abstract expressionism which had its own mystical or metaphysical, almost religious, overtones.

However it is incorrect to use the word "metaphysical" when describing Gold's art. Metaphysical refers to non-physical phenomena whereas macrodimensional refers to physical—call them electrical, or better still plasma—phenomena.

In short, the way in which higher realities are apprehended varies with each generation but the concern remains the same. In this context the title of the image on the right is most appropriate for this discussion.

It will not be surprising to learn that the *Lightning Shaman*—and most everything else in this book for that matter—is a very serious piece if you understand that you are looking at a *topologically* accurate representation of something real. A general unfamiliarity with this sophisticated domain inhibits our ability to appreciate the nature of what is being portrayed. Maybe that is why many of Gold's images are so disturbing, so provocative.

SKY EARTH LIGHTNING SHAMAN (F.P.)
Pastel on Sennelier, 1987.

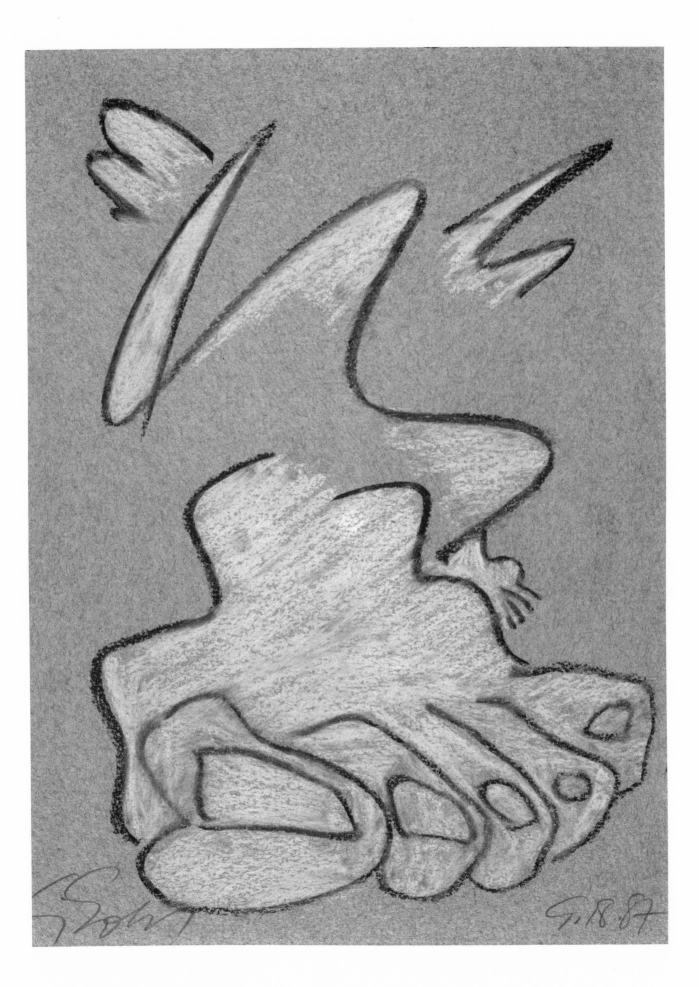

"The nice thing about paper art, as opposed to bronze, is that it makes a wonderful fire-starter!"

E.J. Gold

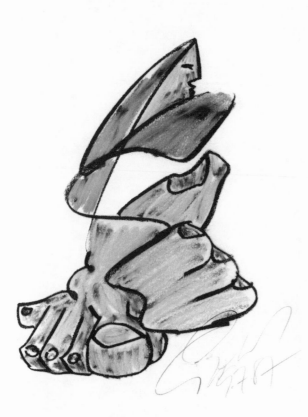

It should not be surprising to hear that Gold has his own cosmological views based on his research in theoretical physics, although he never brandishes them and only occasionally indulges in exciting discussions with the rare visitors to his home who can match his knowledge and intellectual prowess in this area—like John Tompkins, one of the few surviving scientists of the Manhattan Project, or John C. Lilly, M.D., theoretical scientist.

The *City in the Sky* canvases provide the most elaborate examples of his cosmological views, as do the *Planar Contiguities*, the *Cosmo Street Corridors*, and the *Sanitarium* series. But smaller artworks such as the *Open Door* series, and the *Chess Players*, also carry the same unmistakable Gold trademark.

His almost obsessive preoccupation with strange morphologies—and *Not At All Interested* is a fine example of an outlandish morphology—his hundreds and hundreds of renderings of phantasmagorical creatures, his impudent experiments in distortion, elongation, compression, exaggeration, and transgression of dimensional laws reflect his views of spatiality and dimensionality. According to Gold, and practically every modern physicist for that matter, the world as we know it is only a small portion of the entire electro-magnetic spectrum existing in the universe. And that is what he is really trying to convey: the unseen portion from which we are visually isolated by the strictured domination of our cultural model of the universe.

A SERIOUS CASE OF PERSPECTIVE
Pastel on Arches paper, 1987.

**NOT AT ALL INTERESTED
IN THE PETTY CONCERNS
OF LESSER BEINGS** (F.P.)
Pastel on Rives, 1987.

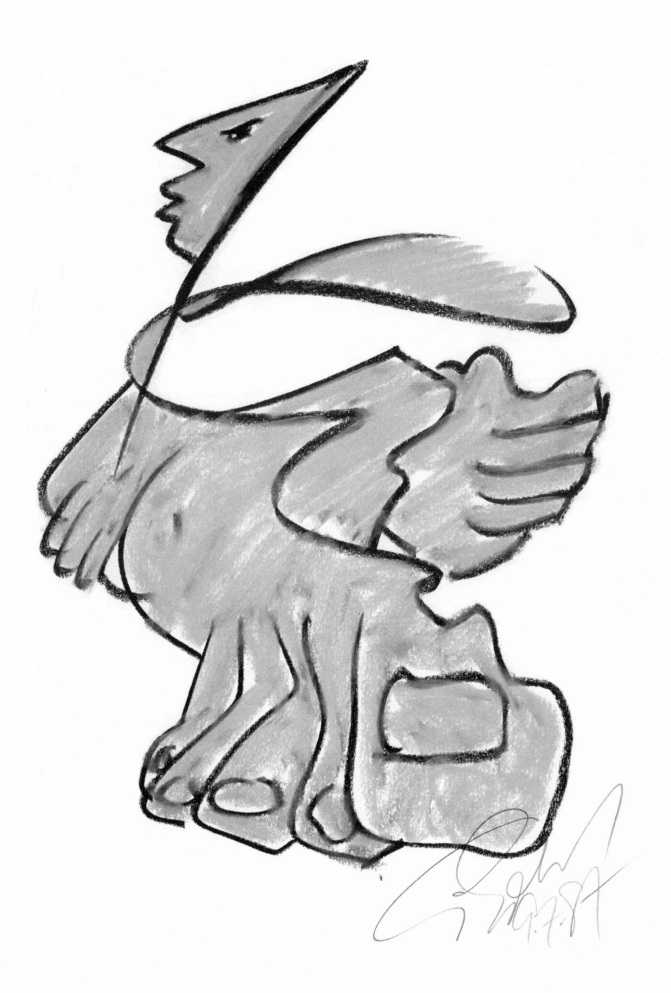

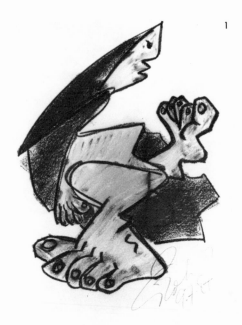

That may be why the strange creatures that populate his graphic world behave more like ambient temperature plasma than heavy particles. That's why his creatures can do anything from stretching themselves infinitely to reducing themselves to a pinpoint, assembling themselves in the most unexpected manner, or walking around as a head on a hand as in *Sailing, Sailing*. This is really quite normal in the spaces which they inhabit.

But it seems as if there is still more to it than that. That doesn't account for our attraction to them and fascination with them. What is it about these creatures that makes them so compelling? Are there things out there that actually look like this? Where is the fine line between whimsy and macrodimensional mirroring?

"I would like to think of my art as contributory to a long line of art science. If my experiments are useful to new generations of artists, if they provoke deeper levels of penetration into unexplored domains, then this is all I could hope to achieve. Whether my work survives in a direct form, or survives only as an influence, it will have achieved its purpose. I don't regard survival as an issue."

E.J. Gold

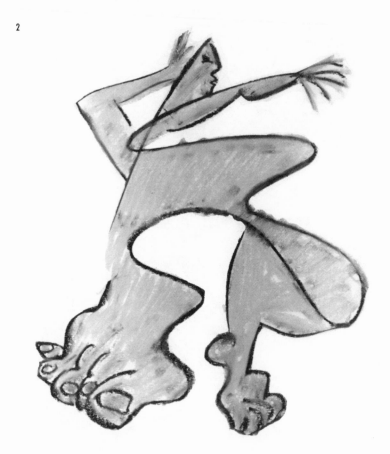

DESERT MADONNA (1)
Pastel on Arches paper, 1987.

**MY OWN BRAND
OF OUTREACH PROGRAM** (2)
Pastel on Rives, 1987.

**SAILING, SAILING OVER
THE BOUNDING MAIN** (F.P.)
Pastel on Rives, 1987.

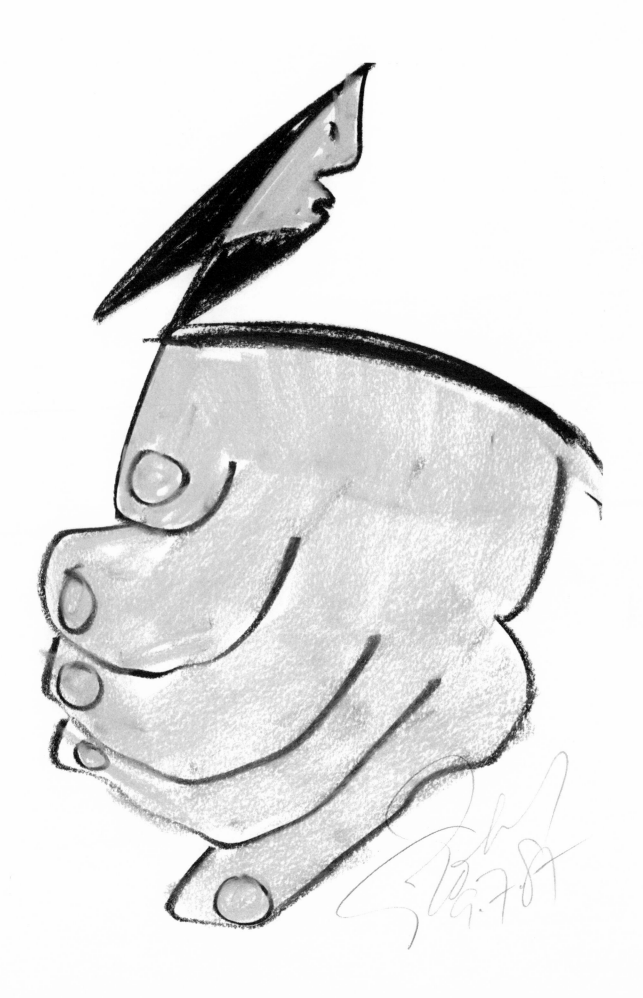

"I have a very specific reason to produce art, and that reason is to get that art placed where confrontations will occur: where an eleven year old kid wandering through the museum suddenly sees this thing, and says, 'This is not this world.' And not only is it a representation of something which is not this world, but it actually kicks him into a viewing position which is not this world, not of the common consensus reality."

—E.J. Gold

"Gold's grotesques arouse uneasy sympathies in the viewer: we recognize aspects of ourselves—elemental emotions—which, for the most part, we are at pains to ignore. At the same time, the pieces jolt the viewer into the momentary awareness of a reality more encompassing than the enclosed spaces ordinarily perceived.

Sydnie Kunin
Amherst Art Associates
Amherst, Massachusetts

PhotoArt by Nona Hatay

To answer that question we will have to turn our attention to the domain of mathematical models and advanced geometries where forms such as these exist not as mere fanciful inventions but as objects that can be described with precise formulae.

Some of these mathematical models have been described by brilliant MIT mathematician, David Christie, in his appendix to Gold's book titled *Life in the Labyrinth*. Interested readers with the appropriate scientific background will enjoy this mathematical material which delves into topology, but its highly specialized nature makes acquaintance with it rather forbidding. The book itself is fascinating and challenging.

**THE DOG IN THE MOON
IS NOW IN SIGHT** (F.P.)
Pastel on Arches paper, 1987.

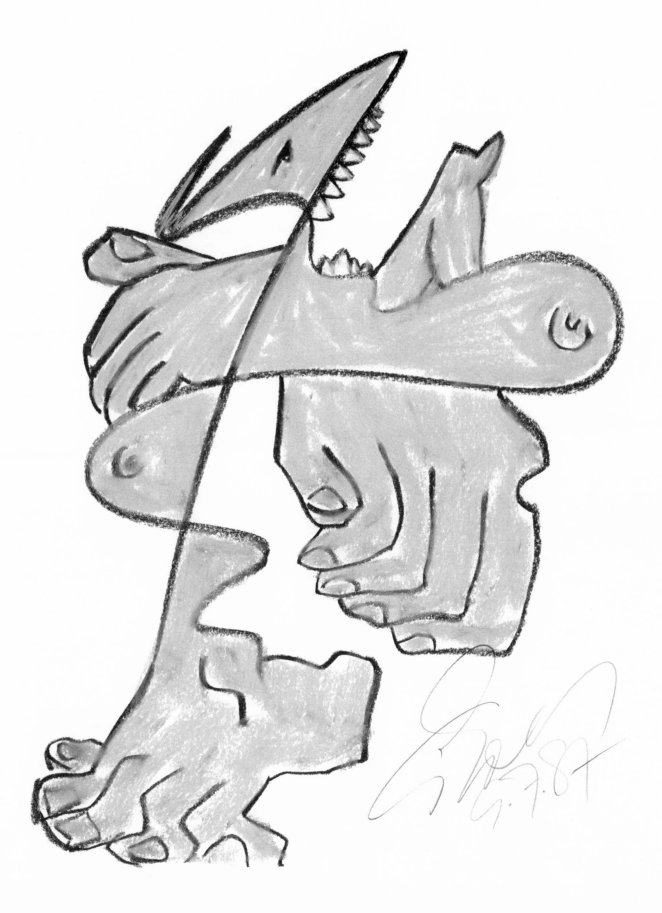

Those who have accused Gold of being too playful, too humorous have obviously missed the point. His humor should never be confused with a lack of seriousness. When Gold is laughing or making you laugh, and *Mambo Italiano* certainly strikes a funny chord, he is quite serious and you can be sure he has something in mind that goes far beyond the smile on your face.

He's not kidding when he talks about the risks you are taking when you walk through a museum and the license it gives the artist to perform his own brand of magic. When you get hooked on Gold's art you will be hooked for a long time.

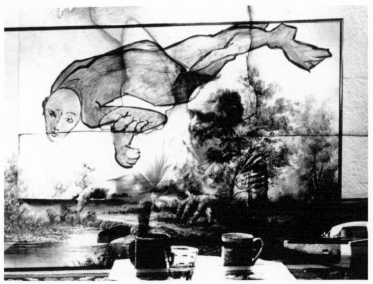

PhotoArt by Nona Hatay

"E.J. Gold's art inspires the senses to awaken."

Robert Bachtold
Art Collector and Consultant
San Francisco, CA

"The introduction of unexpected visual elements obeying different laws of proportion and symmetry, as well as different biological laws produces a juxtaposition of distinct realities which otherwise never coincide. The effect of this juxtaposition is to engender a discomfort in the viewer who cannot hold more than one representation of reality at a time. The juxtaposition therefore questions our basic premise about the nature of reality as we understand it in our everyday viewpoint. It questions the linearity of our perceptions and our interpretations of them."

—"Artists in Resonance" Exhibition Catalog

MAMBO ITALIANO (F.P.)
Pastel on Arches paper, 1987.

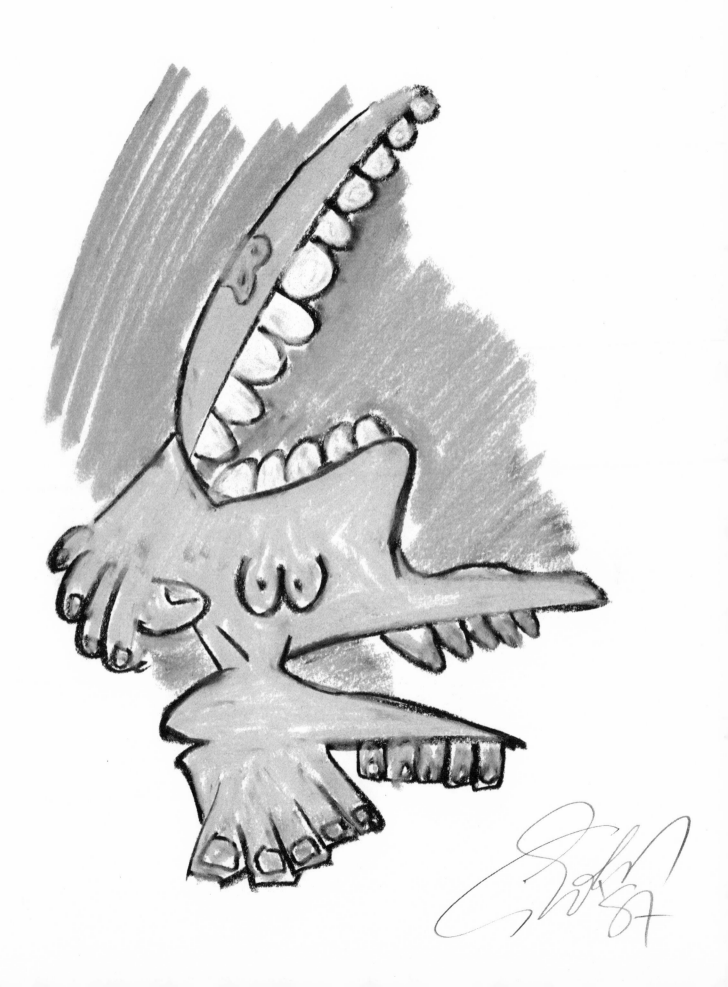

Speaking about a sketch:

"This is just a quick sketch. What I'm trying to achieve here is to suggest a spatial structurization. I'm using distortion—you can think of this figure as representing an actual dimension or representing a universe in itself."

E.J. Gold

Photo Credit: Mariette Fournier

Gold has said that some of his images are similar to the Chinese representations of dragons going in and out of clouds. By this he means that we are seeing only the part of the creatures that correspond to this dimension, that exist in our dimension. The other parts are invisible to us not because they don't exist but because they are *elsewhere*. *The Conductor* is a fine example of this weaving in and out of dimensions.

"Abstraction is an art in itself. It's not a rejection of the figurative. It's a recognition that some part of a human being can enjoy the abstract aesthetic for its own sake."

E.J. Gold

SWEET LIPS, SUGAR LIPS, BOUCHE D'EGOUT
Pastel on Rives, 1987.

THE CONDUCTOR BEFORE HER ORCHESTRA (F.P.)
Pastel on Rives, 1987.

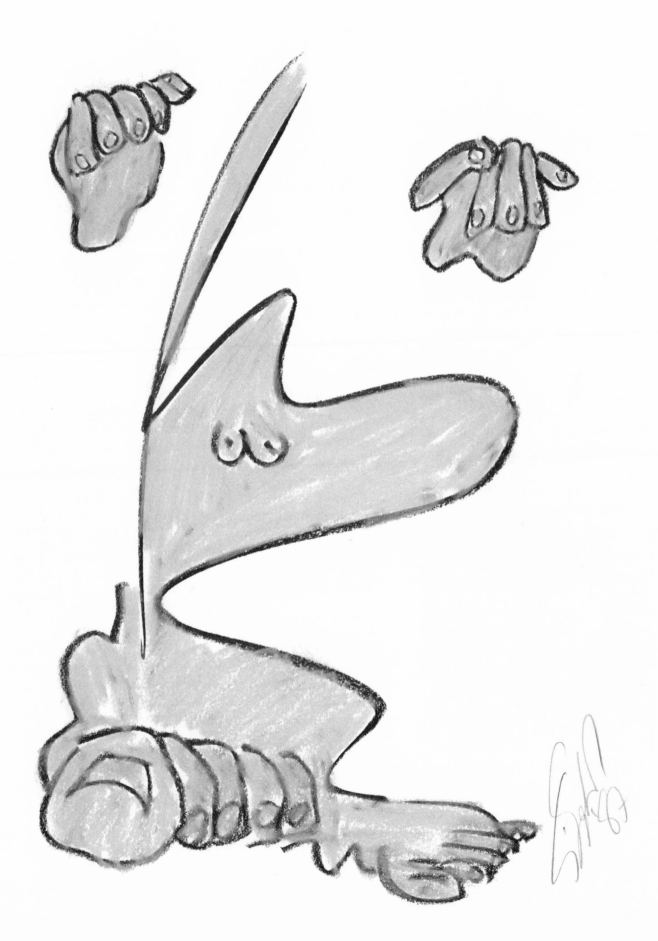

Characters and Voyagers

"For an artist, the only way to really study something is to do it."

E.J. Gold

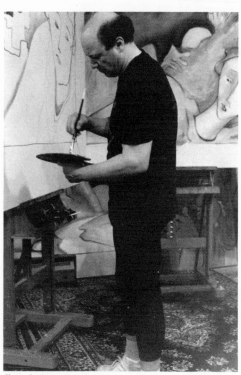

Photo Credit: Mariette Fournier

This final sampling of Gold's gestural pastels creates a sharp contrast with most of the images we have encountered so far. Here the artist has chosen to work with planes and flat surfaces rather than create volume. Although he works with shading, he develops two-dimensional images where three-dimensional ones would have been expected.

The lines have taken a secondary position in relation to the volumes. But there is still a lot of detail that has been included such as toe nails, fingernails, lips, eyebrows and eyelids.

This series produced around the same time period, if not on the same day, is an exercise in distortions and exaggerations. Bold angularity is the common link.

"When I look at a drawing of his, I can sense how it is a kaleidoscopic screen where the reference points alternate and allow different interpretations of the same elements affording many diverging and amusing thoughts."
—Michael J. McDonnell
Art Collector and Antiquarian
Santa Rosa, CA

RIDING THE BROOM (F.P.)
Pastel on Sennelier paper, 1987.

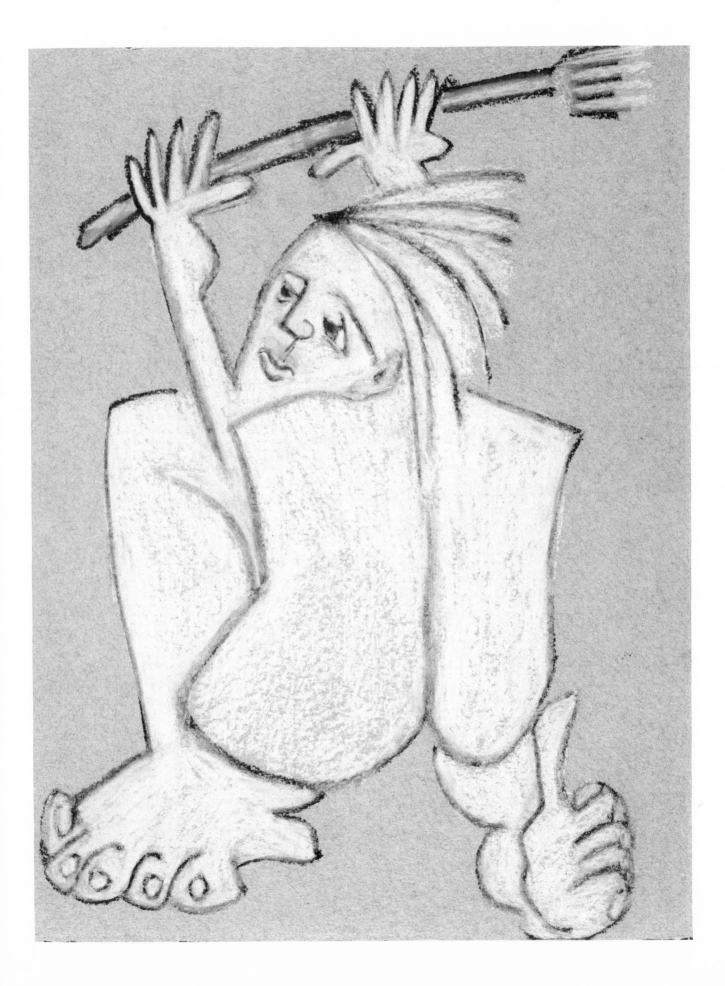

Photo Credit: Mariette Fournier

"The fact is that you're really ultimately alone. When you fully realize this, at that point, what you do, you do for its own sake, for the sake of the art of it. Art for art's sake. You don't do it for the money. You don't do it for the fame. You don't do it for what it will bring you, because it will bring you absolutely nothing. You know this.

"That's one reason why I'm not so concerned with looking unique as I am with exploring the domain, the realm of reductionism. I may not be the artist who actually comes up with the solution to reductionism, and I don't have to be."

—E.J. Gold

As with *Riding the Broom*, *Three Legged Hopper* illustrates the usage of planes. The image layers the surfaces one upon the other without creating depth and produces the illusion of a frozen tableau. This image and the preceding one are closer to representational forms than to abstraction. They also depend on mass to create their effect. The result is both dynamic and static, a curious juxtaposition of movement and stability.

THREE LEGGED HOPPER (F.P.)
Pastel on Sennelier paper, 1987.

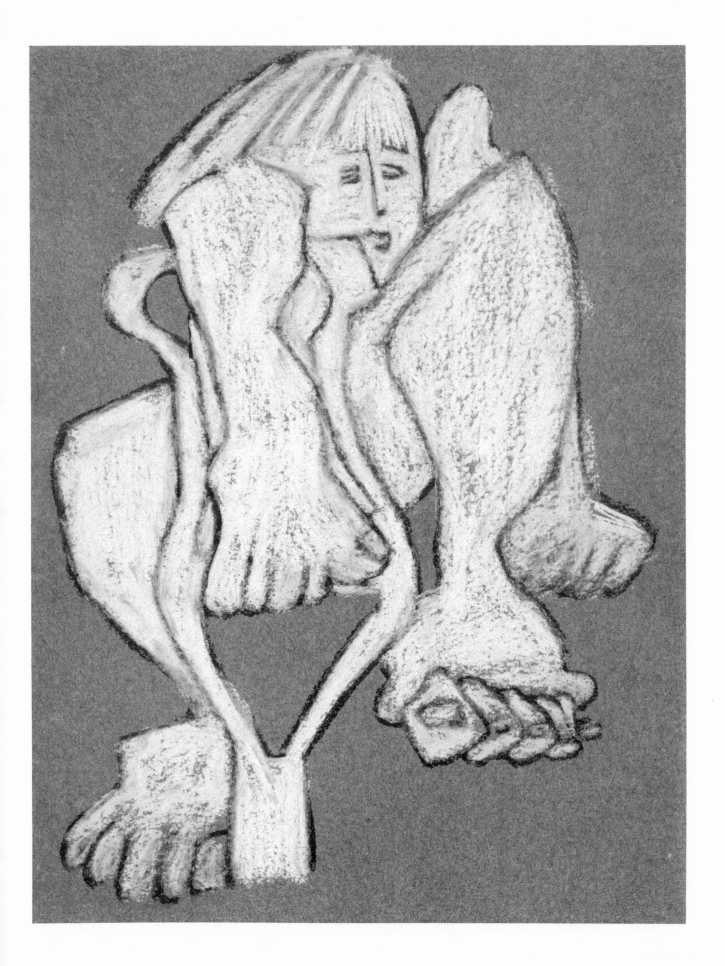

"Gold pulls something out of left field and juxtaposes it with the most ordinary scene leaving you to wonder where you are."

Cathy Inslee
Gallery Director
Philadelphia, PA

"There are a number of attitudes about art that are primate-directed. Among these is the need for everything to be representational, part of a structured view. It's the belief that art should look like something.

"Back when there weren't cameras, art should have "looked like" something. It needed to because photography didn't exist. Art in general served the purpose of making the house look bigger by putting a landscape in, or making the inhabitants of the house look bigger by giving them importance and painting their portraits. Until the camera came along, artists were responsible for portraiture."

—E.J. Gold

This image achieves complete exaggeration of hands and feet contrasting with extreme compression of the torso and head, leaving only a little room for a face to be sketched in. The posture is typical of the precariousness that some of Gold's figures evoke. The marvelous use of compression creates a playful sense of wonder.

PANHANDLER (F.P.)
Pastel on Sennelier, 1987.

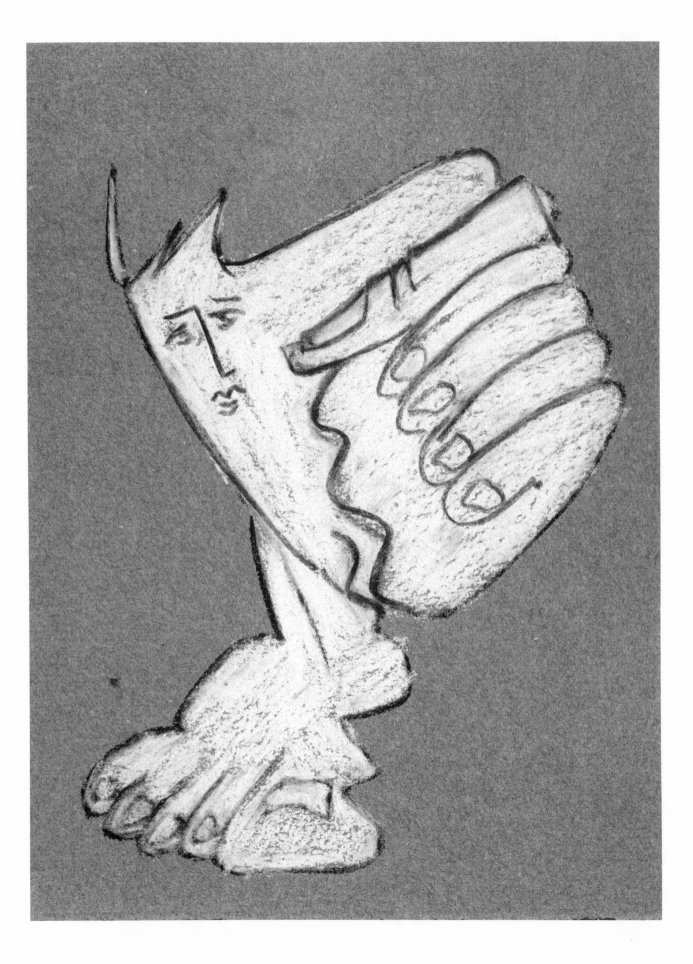

Here we have a wonderful composition where the body has all but vanished except for large feet and an amorphous shape above them not at all recognizable as legs or a torso.

This massive blob, however, succeeds in suggesting critical mass in more or less the right place. Critical mass in this context means the amount of mass it takes to suggest something which ordinarily requires more form to be recognized.

Again the hands floating in mid-air should be viewed in the same way that we perceive dragons weaving in and out of clouds in Persian miniatures and Chinese paintings. The effect is delightfully humorous.

"Gold takes something ordinary and adds something to it, making it suddenly unordinary. He readjusts your perspective, gives you a little shove, makes you look at things in a slightly different way than you are normally accustomed to."

Mark Connell, Director
Connell Foundation
East Haven, CT

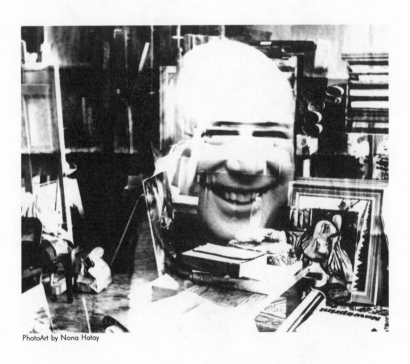

PhotoArt by Nona Hatay

"Sometimes when I'm technically stuck, or stuck for ideas, I go to a different medium. For instance, if I'm painting, and I just can't think of anything else to paint, and my paintings don't seem to be working out at the moment, instead of quitting altogether, what I do is start sculpting, or drawing, or composing some music, or playing some musical instruments. Then when I return to where I was everything is different."

—E.J. Gold

JOY RIDE (F.P.)
Pastel on Sennelier, 1987.

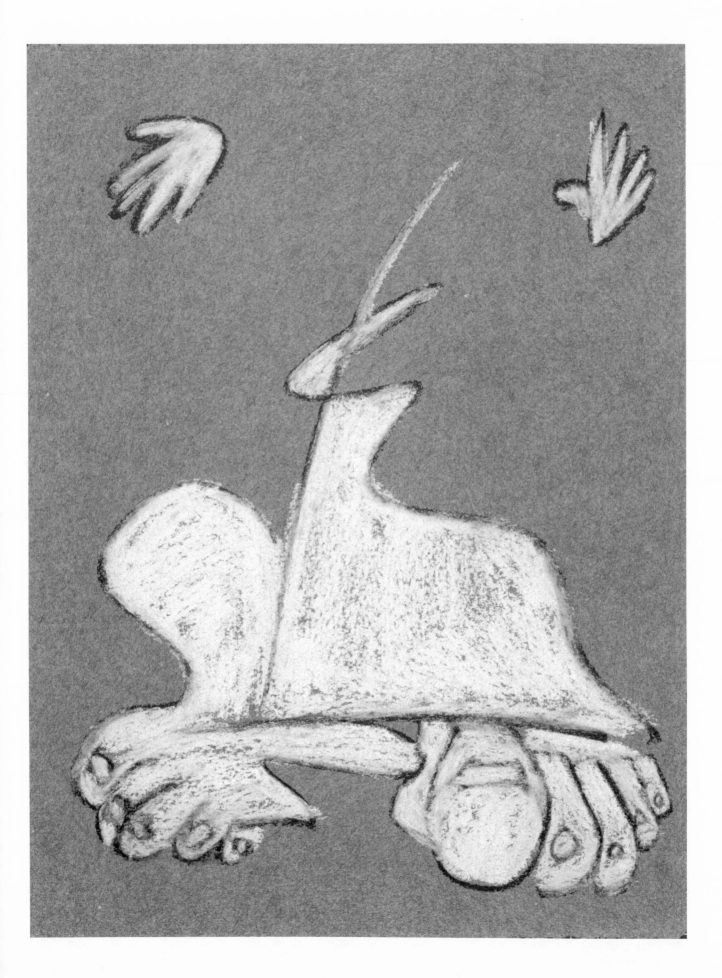

PhotoArt by Nona Hatay

This image is a study in mass. It uses expansion and compression at the same time, producing contradictory impressions in the mind of the viewer. Quite in keeping with Gold's propensity for "Big Mamas" it portrays a figure with huge feet and legs but with no head, leaving us to surmise what happened to it. Perhaps it was reabsorbed into the expanded torso... The hand on the hip could be taken to suggest that it's also wondering what happened... So we'll probably never know!

Gold says that this image reminds him, except for the lack of garments, of a childhood friend's mother in her kitchen waiting for her daughter to figure out what to do with the tomato sauce. One original idea for its title was, *Mrs. De Matteo in the Kitchen*.

"Some people are of the opinion that my style is either erratic, ever-changing, or nonexistent.

"Contrary to popular belief, I do have a style which is unique to my studio and to myself. Viewing a few hundred or a few thousand of my works, the style becomes self-evident. There are some who can recognize my hand without the necessity to refer to signature. I am not one of them."

—E.J. Gold

MOTHER OF SPACE (F.P.)
Pastel on Sennelier, 1987.

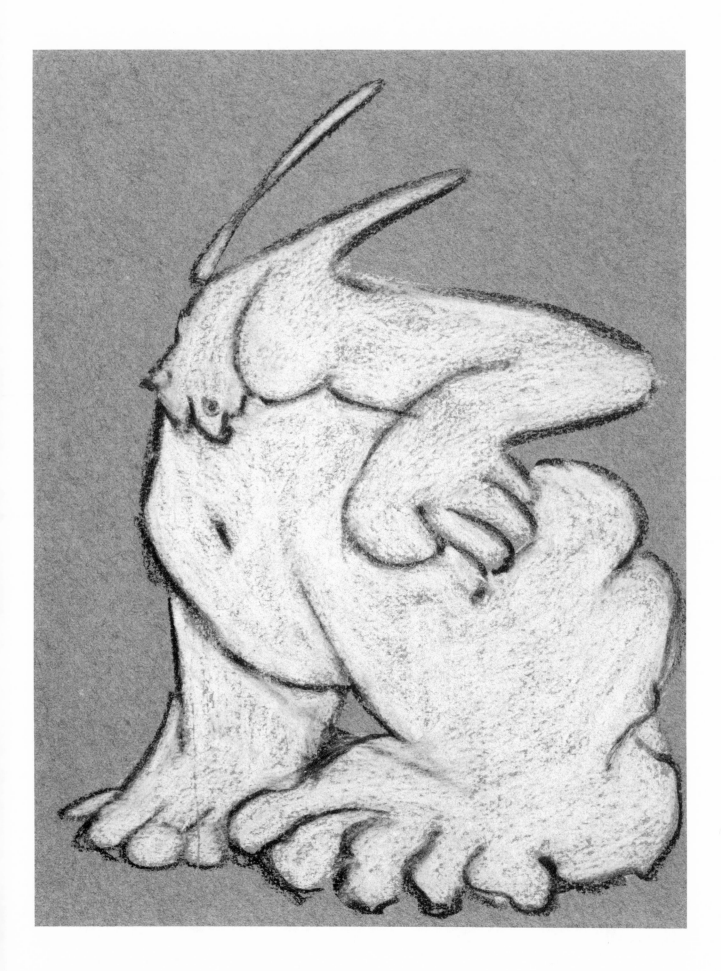

PhotoArt by Nona Hatay

"Gold bears watching since he may be one of a handful of art-workers world-wide who recap the entirety of 20th century art, sift through it for the genuine, and burn off the dross. This action is crucial to the next revolution in art technology—both for artists and art consumers."

Robert Bachtold
Art Consultant
San Francisco, California

"In the conception of an idea one can only have the vaguest notion of a finished product.

"I often have a clear idea of how a work will begin but never how it will come out, because, in the course of painting or sculpting, accidents happen and my work allows for the development of accidentals.

"I follow this in my music as well and my compositions, especially symphonic compositions, utilizing the introduction of accidental harmonics and overtones.

"What I do is sit with the drawing, where the drawing is at the moment. When I'm satisfied that it pulls me in, I stop."

—E.J. Gold

Our last selection in this series breaks many rules. It differs from the preceding ones in its use of compression and movement in a tightly defined line sweep.

The artist introduces abstraction to forms and lines he has explored earlier. With the exception of the face, he has achieved distortions in every direction including the oversize feet, *Flying Boobs*, neckless head, stick arms and stick hands—or are they balloons about to be inflated?

The dominant trait here is a combination of sharp angularity and contrasting roundness. This image indicates a gradual progression toward greater and greater distortions of the limbs and their increasing importance in the overall composition.

FLYING BOOBS (F.P.)
Pastel on Sennelier, 1987.

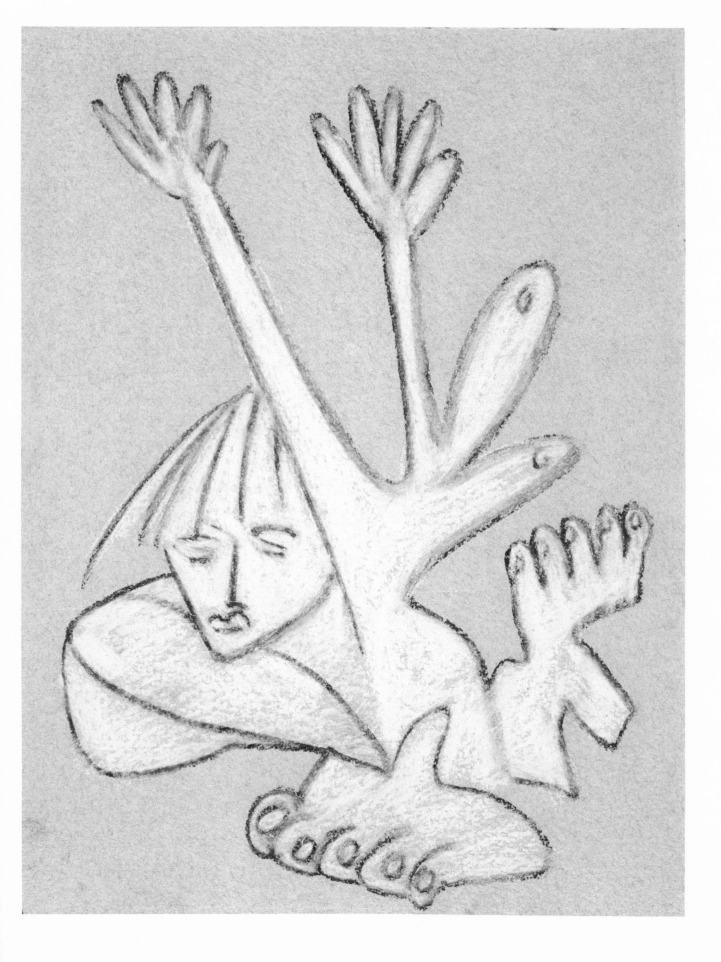

Pure Gesture

In the same way that Gold's smaller works are vehicles for the expression and development of gesture, so his larger works also rely on gesture as their supporting axis. But here gesture takes on new meanings. It alludes to content as well as to form, an intuitive way of communicating, a telegraphed message, a lightning flash, a spark, a means of popping the viewer into a space; it proceeds by hinting at rather than fleshing out. *Pure Gesture* becomes a way of signifying and representing efficiently and economically, paralleling Gold's work in the sixties and seventies which more often than not took the form of an event or a happening.

Although most artists prefer to work out problems in a small format before attacking a project in a larger one, Gold invariably works down from large scale to small scale. His preference for working in this manner is based on the fact that large scale gives him room to move and forestalls the decisions that inevitably must be made when working in small size. Large scale is free and enables the artist to be more faithful to his aesthetic impulses. In this sense his drawings should be considered a distillation of his oil paintings.

This part of *Pure Gesture* will enable us to see some of the results of working in this way. It includes some representative works in charcoal, ink wash, gouache, and especially the more important oils-on-canvas.

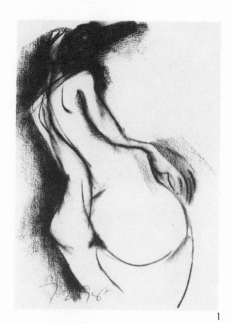

1

Photo Credit: Mariette Fournier

2

Macrocosmic Models

Gold has expressed a particular fondness for charcoal. Scrutiny of his work in this medium soon reveals an artist comfortable and at ease within it, in full control of what it has to offer, capable of the finest nuances within the confines of black and white surfaces.

The charcoals possess a subtlety quite distinct from that which we encounter in his pastels. They encapsulate a world of shadows and darkness that has no comparison elsewhere in his work. Depth of mood and a pervading sense of mystery distinguish them from every other medium. In fact some of his most haunting images are in charcoal.

Gold has produced numerous portraits, and studies of nudes and torsos indicating, like more and more artists today, a returning preference for the use of figures. This present book can only show a few of these where there are countless thousands more worthy of attention. *Leaning Nude* has a beautiful line. *Phantom Form* shows the application of distortion in proportion.

The use of gesture takes on a different aspect when applied to charcoal. Here gesture comes to signify curve and movement created not so much by the sweeping line but by the *absence* of line. Definition of form appears through the use of shadowing, the sharp contrast of light and dark. Shadows delineate and outline. They provide depth and perspective. Gold insists that he has Bentley Schaad to thank for his proficiency in the use of light and dark.

PHANTOM FORM (1)
Charcoal on Arches, 1987.
Lithograph on Arches, 1987.

LEANING NUDE (2)
Charcoal on Rives BFK, 1987.

FIGURE STUDY (F.P.)
Charcoal on Arches, 1987.

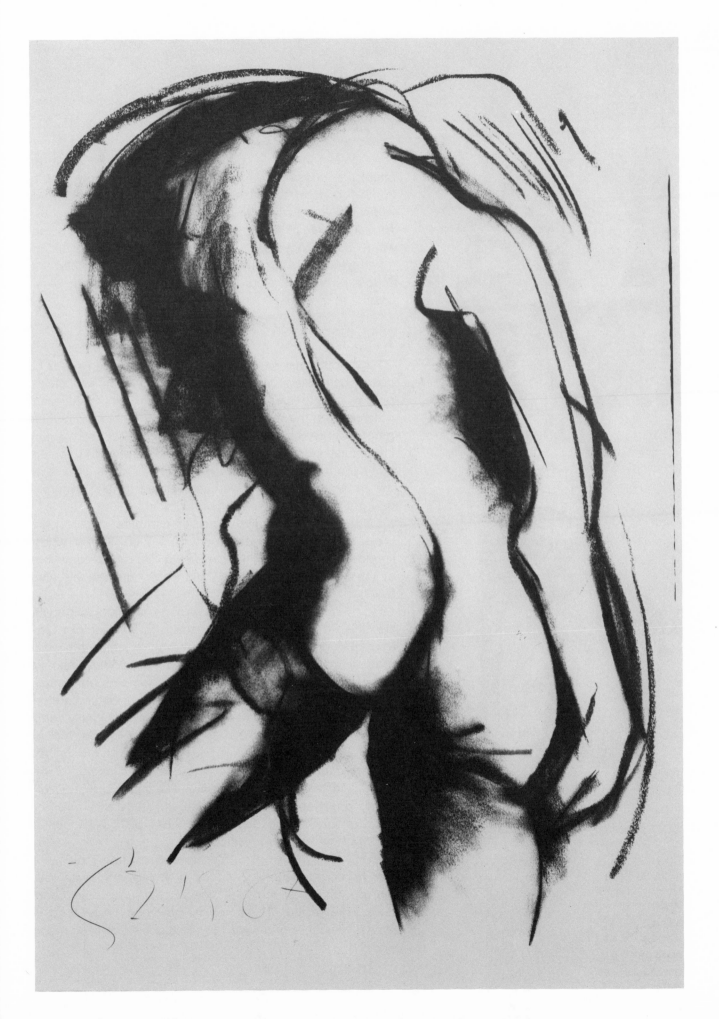

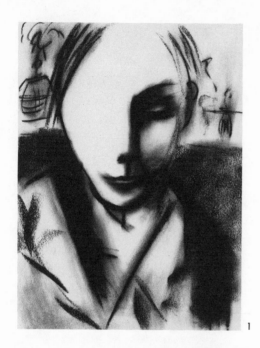

1

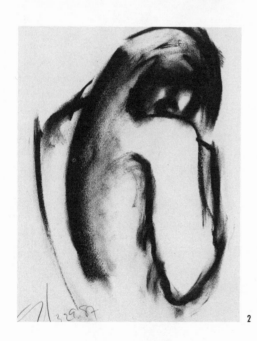

2

"When the art is coming through, the artist is like an interested observer; you're not running the show, you're looking at it at the moment of creation, and afterward, when it's time to sign the piece, you feel funny, because you didn't really do it, it did itself, it came from somewhere so far beyond our seeing that we can't even imagine what the source must have been... I guess there's a certain amount of credit due to the artist for dipping the brush into the paint."

—E.J. Gold

Another key to understanding Gold's technique is his use of negative space. With the precision that we can expect from a perceptual scientist like himself, Gold exerts pressure on the eye by crowding his subjects, leaning greatly on the effects discovered by Bernouilli and Venturi. He applies many laws and effects of physics to the perceptual dynamics of painting, some examples of which are his use of several visual phenomena related to fluid dynamics and gating mechanics.

The use of negative space as a source of perceptual pressure and relief he learned from Rico Lebrun whose lineage is sometimes linked to Goya. Lebrun became one of the major influences on Gold as an artist in his early twenties.

He first encountered him through his association with the Otis Art Institute in Los Angeles and the Comara Gallery. Lebrun taught him many secrets for which he is still grateful today. Their relationship developed into a friendship and Lebrun soon became for him not only a voice of authority in art but also a model of determination, courage, and steadfastness. The lone, if not lonely, artist who works in spite of the outside world, in spite of lack of recognition, and indifference toward real artistic experimentation.

Gold had an early lesson in the difficulties of surviving as an artist in our society. He watched Lebrun waiting decades for that big commission that would allow him to do what he wanted, without compromise. Lebrun considered all of his work preparatory to a large-scale work that never happened. Gold as a young artist witnessed Lebrun, Kline, Pollack and others suffer under the capricious yoke of the art market; he saw and understood its utter ruthlessness and held himself aloof from it for twenty years.

INSIDE OUTSIDE (1)
Charcoal on Arches, 1987.
Lithograph on Arches, 1987.

AND NOW A TOWEL (2)
Charcoal on Rives BFK, 1987.

PETER LORRE, JR. (F.P.)
Charcoal on Arches, 1987.
Steve Kunin Collection.

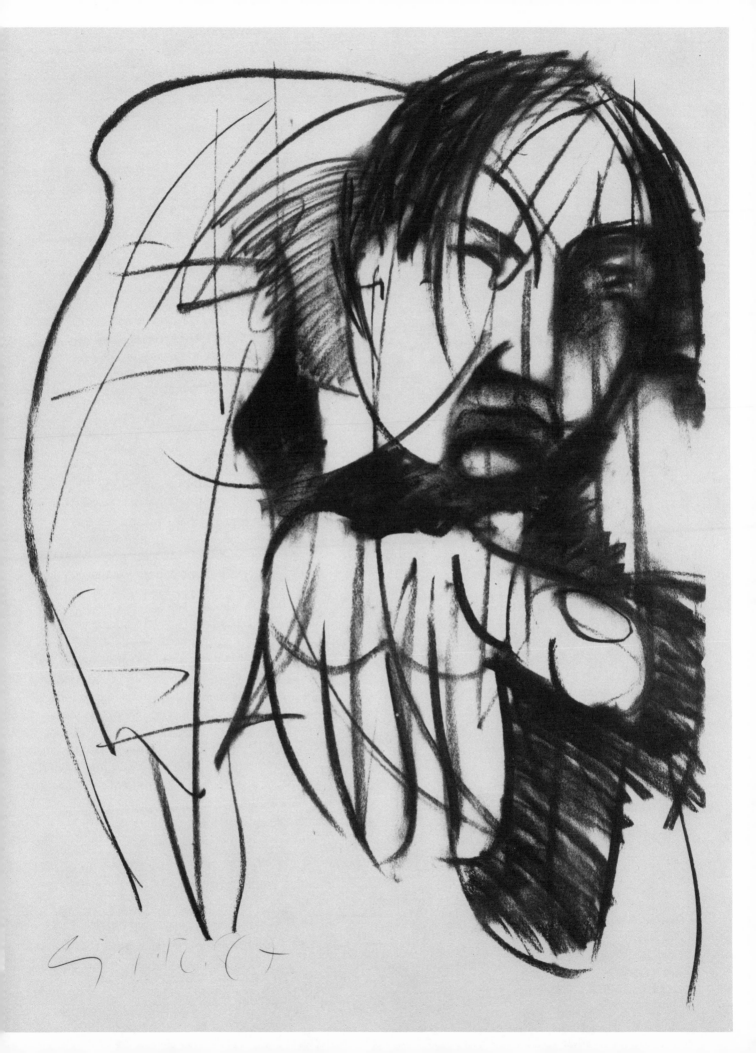

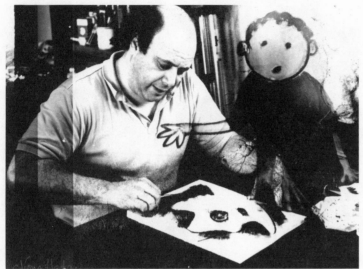

PhotoArt by Nona Hatay

*"Intense artistic fugues take getting
used to. Many artists burn out on
them because they don't know how
to pace themselves, to relax, to get
past the orgasmic spasm and heavy
emotional drenching of descending
muses."*

E.J. Gold

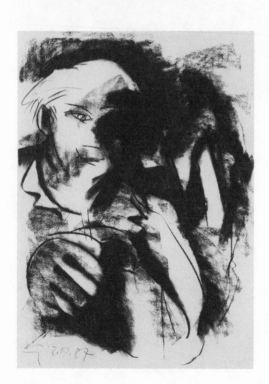

This early exposure possibly reinforced Gold's attitude about "being able to work in the face of indifference," an idea attributed to Miró. He often reminds students of that famous quote.

Gold had a profound respect and admiration for Lebrun, recognizing the vastness of his talent and the monumental scale of his work. Even today, he still believes that Lebrun was one of the greatest American artists of this century and predicts that he will be more widely recognized with the passage of time.

Of all the things that Lebrun taught Gold, charcoal stands out as the medium which left its deepest imprint on him. Gold may have inherited his depth and complexity from Lebrun, but the morbid atmosphere that characterizes much of the latter's work is often—although not always—absent in Gold's. Interestingly, Schaad and Lebrun both use skeletal structures as motifs. Occasionally such skeletal shapes emerge in Gold's drawings, but only rarely. When they do, their origin in Lebrun's work is unquestionable.

*"Gold's work is life as art—an autobiography of the
viewer, an indelible memory of emotion, a reason to be
alive."*

—Toni Raimo
Fine Books, Columbia, PA

ME AND MY SHADOW
Charcoal on Arches, 1987.

FIGURE WITH CRUTCH (F.P.)
Charcoal on Arches, 1987.

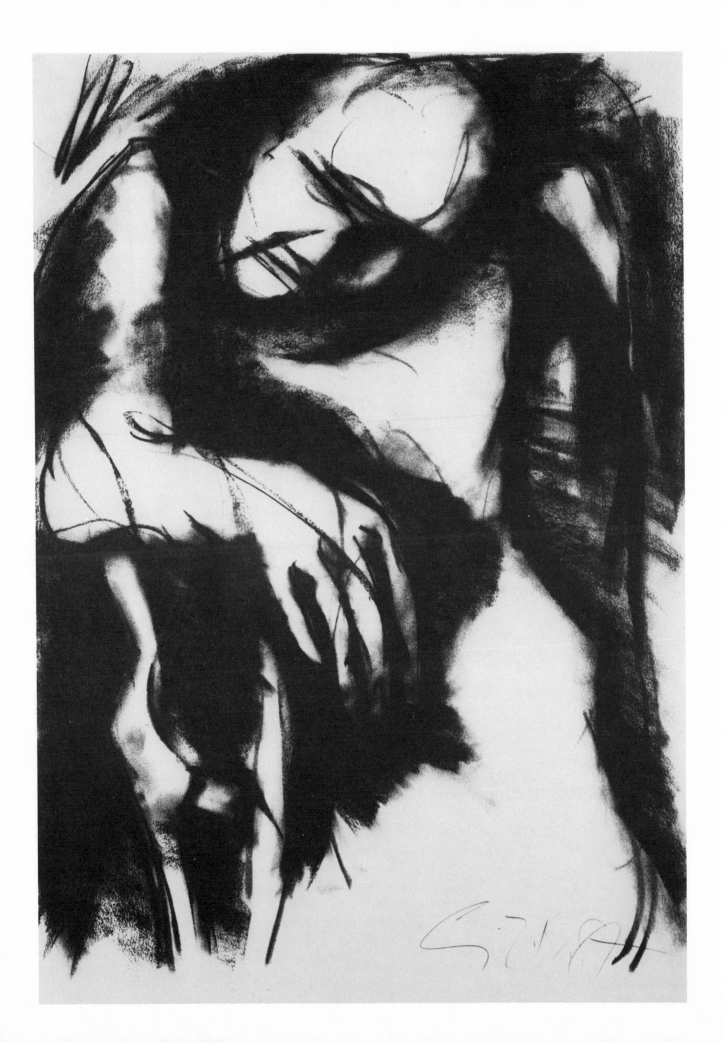

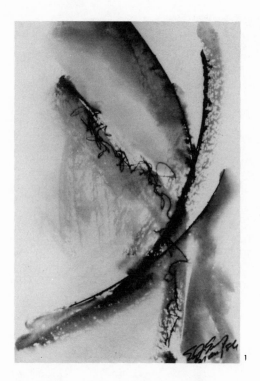

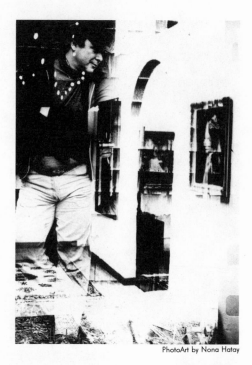

PhotoArt by Nona Hatay

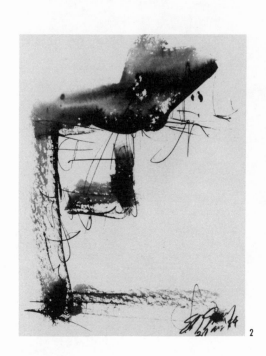

Macrolandscapes

Gold's abstract ink washes certainly merit the attribute of *Pure Gesture*. Here we find the artist producing one effect after another by sweeping his paper with broad gestures, alternating with thick or thin pigment, washing away or deepening the impact of the ink as it meets the paper on which it is laid down.

Nowhere more than here is the oriental influence so apparent. In the mid-sixties, Gold experimented briefly with the Gutai School, the school of "moment-by-moment" art, as he describes it.

He relates that at dawn, he and his fellow students would rise to go and paint on the surface of a cold stream. No one but the artist, not even the teacher, would witness the results of the ink being painted on the surface of water—a substitute for paper surface—and rapidly carried away by the rushing stream.

This experience taught him the Eastern view of art, that the art object is in flux, that it never remains the same, that it will change once the artist has put on the finishing touches. The demonstration couldn't have been more explicit: by being washed away in water, the sculpture or painting, because change is so rapid, is easily seen to be a completely new sculpture or painting from moment to moment, even long past its destruction as a recognizable "art object."

BALLET DANCER IN WASH (1)
Ink and Wash, 1986.

BUG (2)
Ink Wash, 1986.

TUMBRIDGE WELLS (F.P.)
Ink and Wash, 1986.

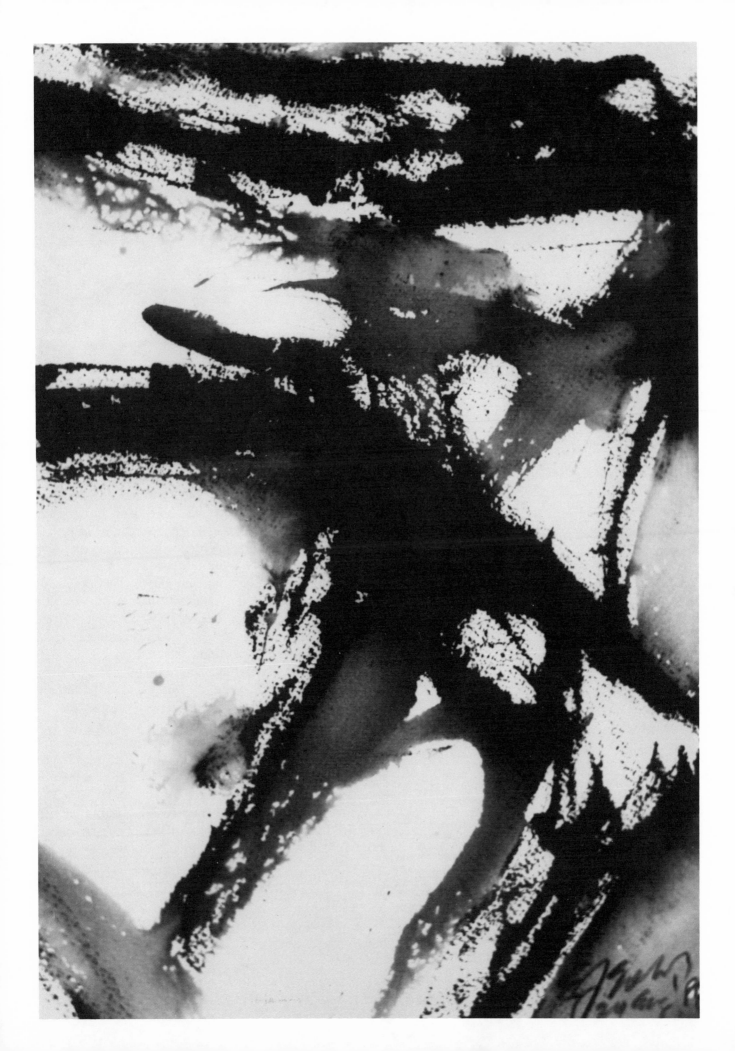

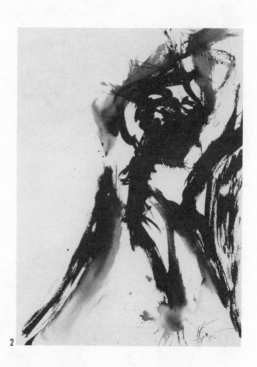

"As in any other science, works are exhibited, which is the equivalent of publication, with the intention that other artists will utilize and apply what has been learned in those experiments. In such an atmosphere of cooperative experimentation there can be no proprietary concerns."

E.J. Gold

In the Western view, the artist is finished with a work when it is delivered to a customer. In the East, a piece is never finished, it is constantly in flux with nature. The concept of the Gutai is to grasp the artwork in the present exclusive of persistence. The next time you look at it, it is infinitesimally different. It is interactive with nature and with people; psychologically a work is never the same twice. It never surprises you in the same way again. Two appreciations one second apart are different. This is perhaps the most important lesson Gold learned here.

This uniquely personal and intensely subjective experience of art had a profound influence on Gold's outlook concerning the objectification and reification of the artistic process. That is probably why he is so adamant about the idea that art is not meant for the marketplace.

The miniature series to the left provides a rich demonstration of the continuity that exists between images in a series and the diversity of style which has sometimes been used as a critcism of Gold's work. Again the influence is markedly oriental.

All of the images in this chapter demonstrate his use of negative space. Large sections of the paper on which he has worked remain empty and bare. The relationship between the two is what creates the dynamics of pressure and movement of the overall composition.

MOVEMENT GESTURE I - V
Ink and Wash, 1987.

FOREST DANCE II (2)
Ink and Wash, 1986.

FACE IN THE WINDOW (F.P.)
Ink and Wash, 1986.

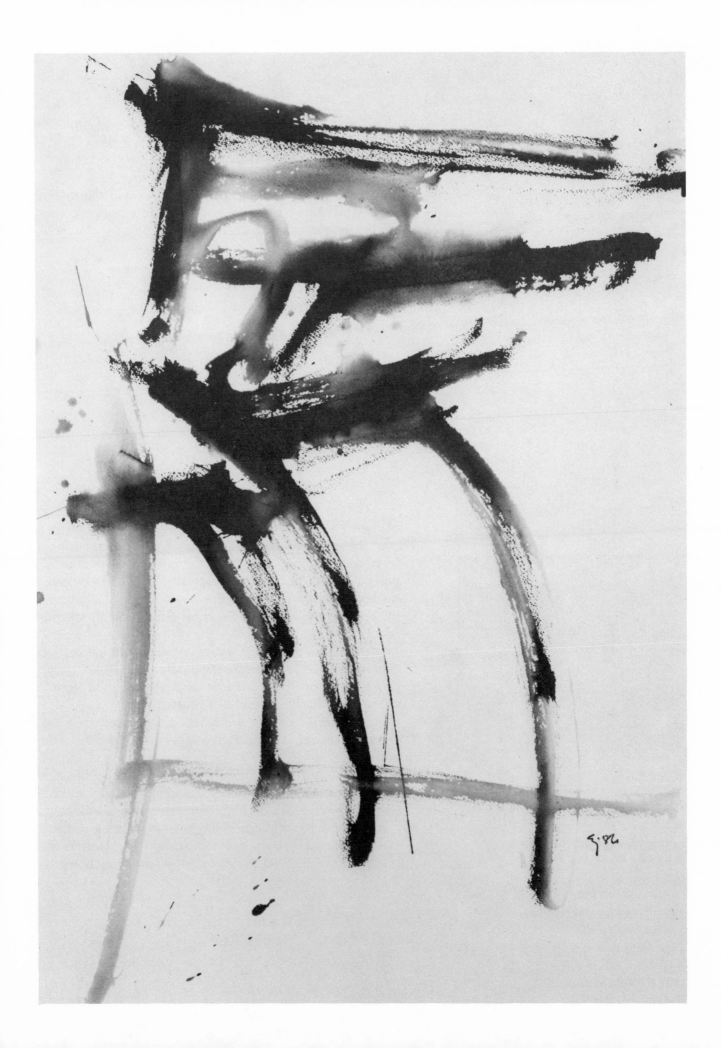

1

"I see in Gold's art the dawning of a new classicism. He starts where Matisse, Miró, Picasso but also Gabriele Münter, Fritz Schwaderer, and Ernst Ludwig Kirschner left us, with many aesthetic questions unsolved.

"Seeing the fortitude of his disegno and the integrity of his concetto we are witnessing in Gold's work a contemporary renaissance of the figurative. This is clearly the trend of the '90s."

—Klaus Schürmann, Publisher
Propyläen Verlag, Berlin

Planar Contiguities

2

These paintings are the culmination of a succession of experimental transitional steps which Gold has taken over the years to question perception and perspective in both aesthetic and philosophical terms. It synthesizes his prolific output of gesture figures in a wide variety of media, as well as his spatial experiments which began as far back as the mid-sixties with his *Cosmo Street* ink wash series.

These breakthrough works in which he denies perceptual context and perspectivist reference open exciting possibilities for further artistic explorations and form a strong basis for the school of Reductionism.

This series of oils-on-canvas is the result of Gold's experimentations with forced perspective and color compression.

Although steeped in the classical tradition, this series incorporates the technique of Japanese Sumi-e brush painting which relies on both immediacy and permanence. The irreversibility of the drawing imposes a decisiveness in the exercise of gesture and application of brush strokes which lends vigor and drama to the expanse of canvas.

GATHERED UP AND READY TO GO (1)
Oil on Masonite, 48" x 60", 1987.

SISTERS IN SPIRIT (2)
Oil on Canvas, 60" x 96", 1987.

JUST OUT FOR A MORNING STROLL (F.P.-TOP LEFT)
Oil on Masonite, 48" x 60", 1987.

A SOFT JOB (F.P.-TOP RIGHT)
Oil on Canvas, 48" x 60", 1987.

A WEE SLIP OF A GIRL (F.P.-BOTTOM)
Oil on Canvas, 60" x 96", 1987.

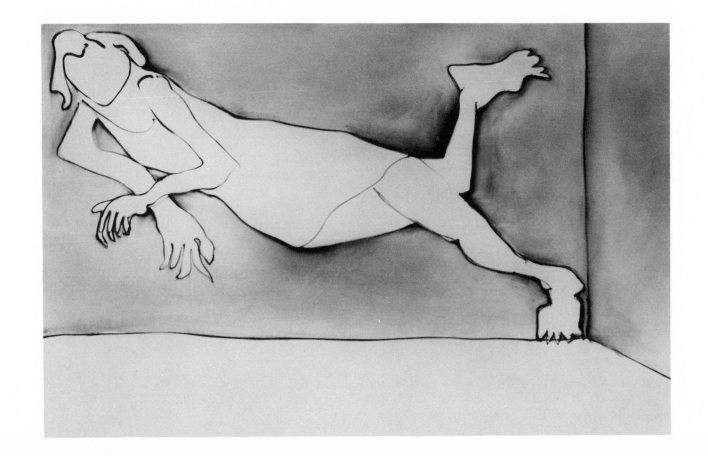

"Gold's work in many genres certainly indicates
a visionary of the first order."
—Tom Johnson, Artist
Nevada City, CA

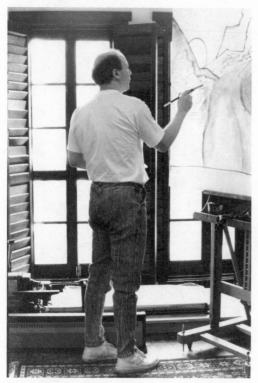

Photo Credit: Mariette Fournier

The power of these paintings and the nature of the breakthrough they announce is defined by the figure/ground relationship. This relationship is established by the exposed canvas primer in both the figures and the floor plane. The absence of paint in both areas is a visual indication that the figures and the floor are in the same plane.

The use of open-canvas planar relations negates the norms of neo-classical illusionism defined by lines of perspective, diminishing planes, and vanishing points, and supports another form of illusionism not dependent upon apparent perspective and distance. This plane-to-plane relationship is similar to the integration of figures and numbers used in early Da-da and Cubist compositions, for example, as a means of undermining the three-dimensional pretensions of a two-dimensional canvas.

The juxtaposition of raw canvas beside painted canvas reminds us that paint perceptually annihilates the continuity of the canvas. At the same time, the raw canvas denies illusionism and points to the fact that the perception of dimensional illusion leads us away from the truth; it also restructures the flat surface into a multi-planar perspective, and thus establishes an intriguing planar ambiguity inviting further psycho-emotional inquiry and perceptual penetration.

REALLY REACHING FOR IT
Oil on Canvasboard, 20" x 24", 1987.

IN REPOSE (F.P.-TOP)
Oil on Canvas, 60" x 96", 1987.

ON THE LINE (F.P.-BOTTOM)
Oil on Canvas, 48" x 60", 1987.

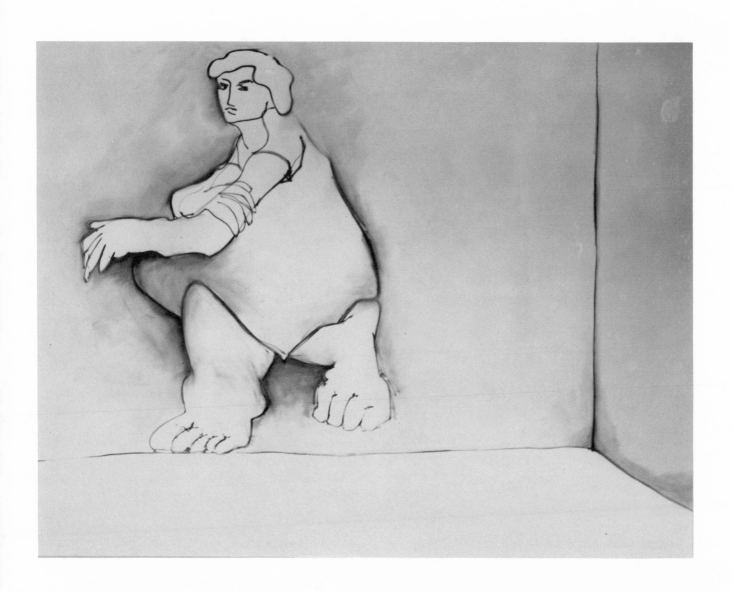

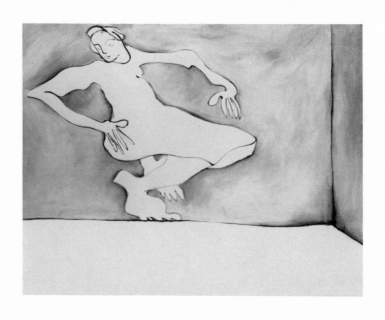

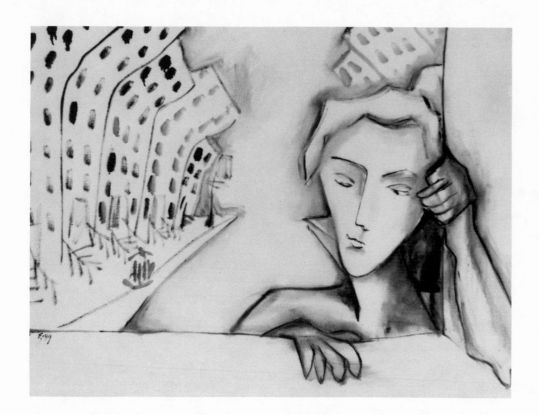

*"A recognizable and personalized
artistic style has no meaning outside
the market place. The experimental
artist works toward a deeper penetra-
tion of reality, and if economic con-
ditions permit, sells only those works
which fail to meet that requirement,
retaining the successful works for
public exhibition as whole and
unified groups."*

E.J. Gold

Contrary to expectations, the figures and the ground produce the effect of dimensional illusion. Because the exposed canvas of the figures is perceived as having dimensional depth and perspective, the ground plane also seems to have dimension and perspective. This is a direct consequence of the mind's tendency to organize and assemble perceptions into manageable groups.

Gold seems to easily create the illusion that his figures float forward and backward in relation to the wall plane, alternately advancing and receding in a pulsating dance. This constant fluctuation is stimulated by emotional and visual neuro-triggers. The illusion changes with the perception of the viewer which in turn changes according to the structurization of imposed perceptual models and constructs reinforced by reflex and further modified by explanatory, descriptive and conceptual models.

The premise for these compositions is at its best when one cannot decide whether the figure is in front of the wall, against the wall or behind the wall. Whether it is dancing in mid-air, suspended between planar dimensions, or firmly grounded seems to change quite readily from one moment to the next.

PLANAR CITY #3
Oil on Canvas, 39" x 56", 1989.

SYMPOSIUM (F.P.-TOP)
Oil on Canvas, 60" x 96", 1987.

BEBOP MAN (F.P.-BOTTOM)
Oil on Masonite, 48" x 60", 1987.

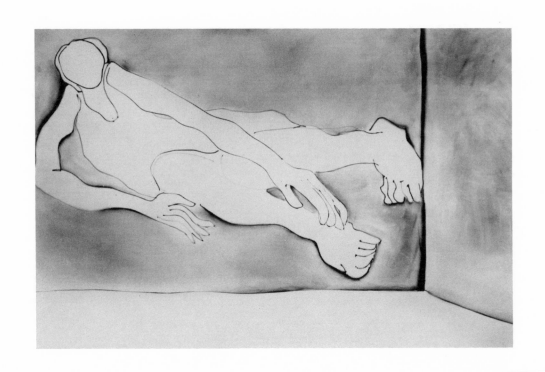

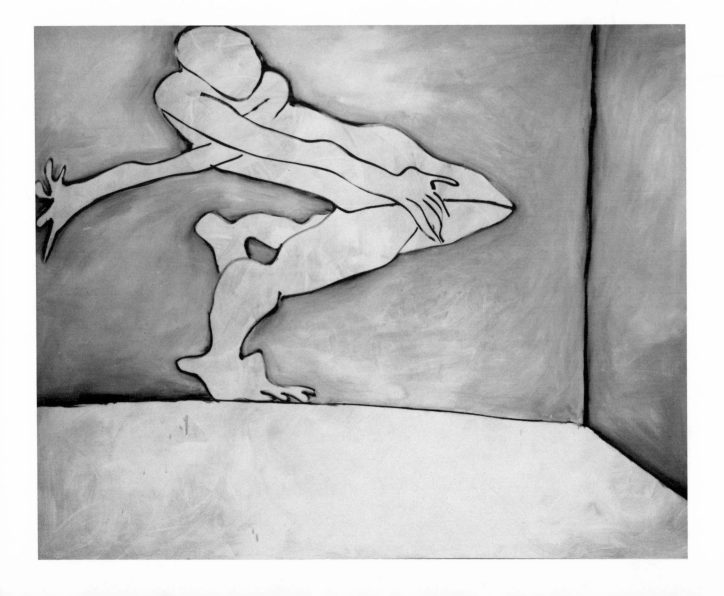

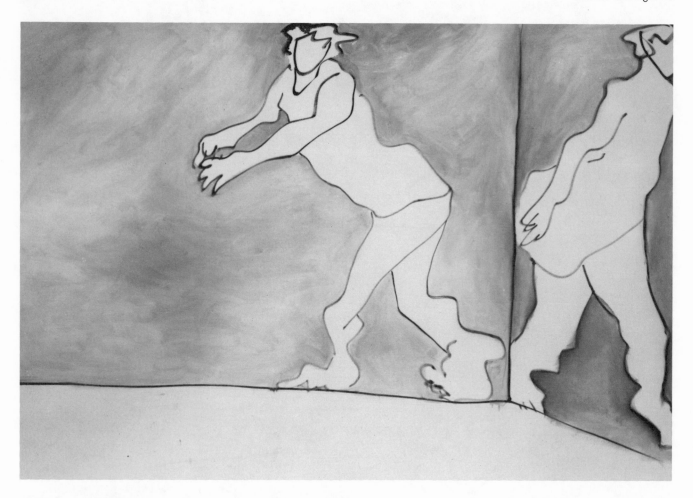

"E.J. Gold's art borrows from and
puts us in touch with the world of
the archetype—awakening sen-
sations of the ancient and the
immediate. Remain alert; there
are many things hidden here."

Jerome Berman, Director
California Museum of Ancient Art
Los Angeles

Feelings about the paintings tend to change rapidly,
perhaps due to the fact that no single mood is allowed to
develop. Therein lies their strength. Gold's oil paintings
often evade immediate understanding and require
repeated exposure and study.

The various moods are achieved with the help of a
subtle palette of grays, browns, whites and blues in the
form of color compression which we could also call a
non-prismatic view. The mastery of palette is unques-
tionable, and yet, if one hopes to find highly formal
finished paintings in the classical late Renaissance style,
disappointment lies ahead, for Gold offers paintings
grounded in high Renaissance technique but ruthlessly
stripped of their emotion-overloaded color; this takes the
viewer beyond aesthetic pleasure into realms of ambiguity,
where one is faced with an utterly uncompromising reality
of unknown dimension, which only a master of illusion
could create.

BRIGHTSIDE CROSSING
Oil on Canvas, 44" x 60", 1986.

PARTNERS IN TIME (F.P.-TOP)
Oil on Masonite, 48" x 60", 1987.

PLANAR WITH CITY IN THE SKY (F.P.-BOTTOM)
Oil on Canvas, 36" x 48", 1989.

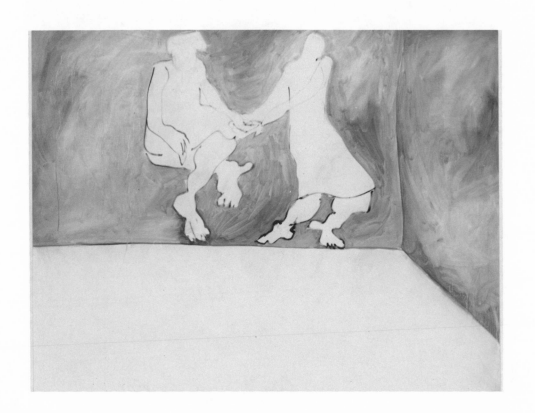

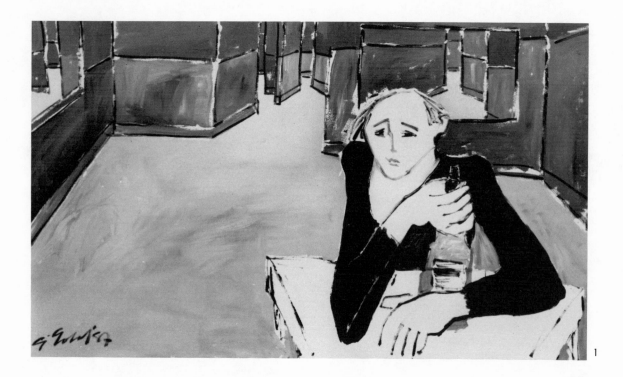

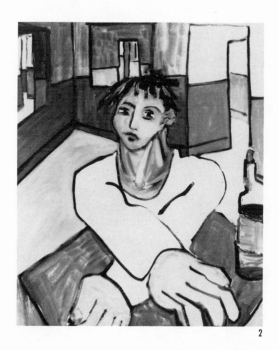

Sanitarium Series

It could be argued that not only does Gold produce gesture in and as form but that he also uses gesture as a means of communicating, that his communication is itself a form of gesture. To say that the content of an image is an act of gesture means that it has been emptied of superfluous language and reduced to its bare meaning.

The images in the large canvases reproduced in this chapter can help to understand this idea. In the *Sanitarium* series we are confronted by an unmistakable setting. Bare walls surround figures usually seated at a table, sometimes with a bottle in the hand or nearby. The walls often have a stripe, but more importantly they lead into a labyrinthine maze.

Occasional openings indicate different directions, and potentially endless chambers to explore beside this one. But from the point of view of the figure sitting in the chamber, the maze always leads back to the same place. In a sense, the maze is an illusion, a dream....

The room we see is the only room there is of that type. The specificity of the objects in it could probably be just about anything, because the objects, like the room itself, are archetypal. We are looking at the quintessence of constituent items in a chamber which is itself quintessential. The archetype of a space which contains itself.

RED BOTTLE (1)
Oil on Canvas, 48" x 98", 1987.

A STRANGE EVENING (2)
Oil on Canvasboard, 20" x 24", 1987.

A BOTTLE OF SPIRITS (F.P.)
Oil on Canvas, 36" x 48", 1987.

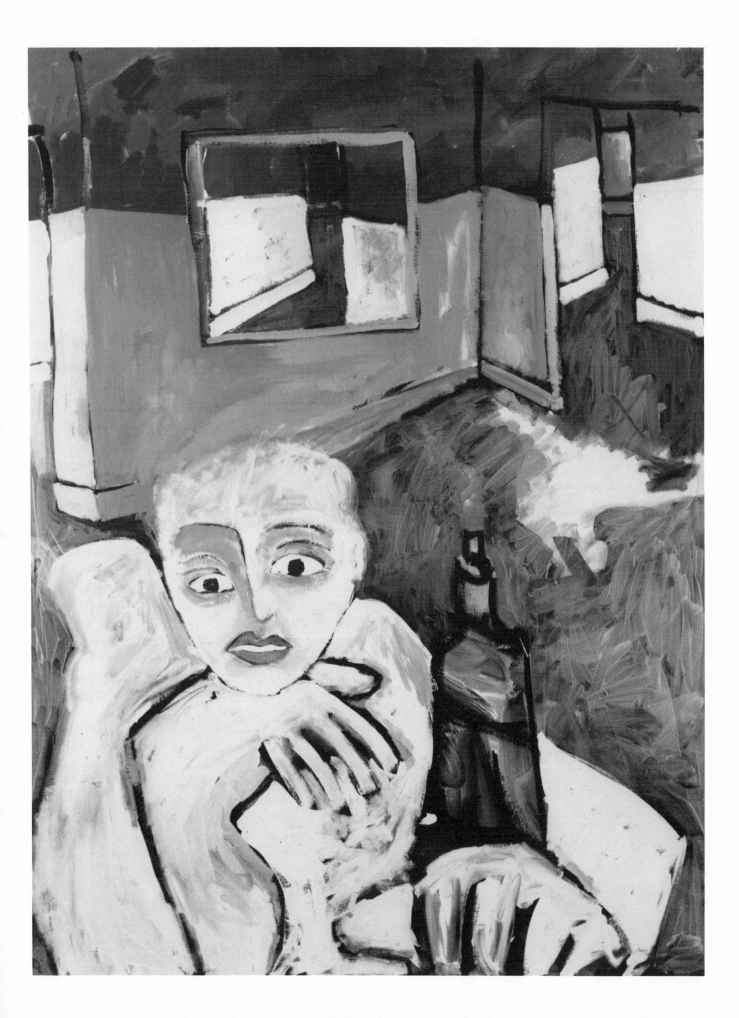

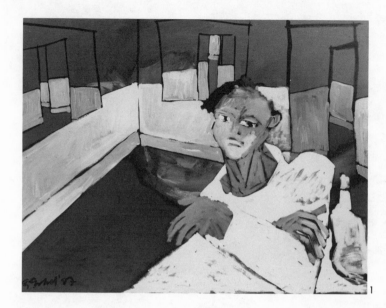

"A painting is a learning experience. I tend to take a painting right up to the point where I lose control of its direction and resolution."

E.J. Gold

"The lines are so utterly simple and fluid, and yet the message is so clear to the viewer. We continue to be enchanted by our gesture art day after day."

Bruce and Caryn Renfrew
Art Collectors
Nevada City, CA

This implies that the qualities that we perceive are from the realm of the Platonic Ideal. They have more to do with beingness than with corporal reality. All apparencies of naturalism have been taken away from them. A bottle here is not an ordinary bottle, it is a symbol. Just as the table, the chair, the door are all symbols of a higher macrodimensional reality, or an inner reality.

The figures are completely inseparable from the chambers in which they reside. They *are* the chamber just as much as the chamber is *them*. The idea of the inseparability of beingness from space is present in all of Gold's deeper, more important works. Being is inextricably caught up in space and cannot be freed from it. Where there is being there is eternal watchfulness, unrelenting sentience, inescapable living presence; sometimes oppressing, sometimes liberating.

Many of these oils convey an institutional anonymity. They have an unforgettable setting which reminds one of a hospital ward—which is what inspired their title to begin with. The mindset which they reflect and the mood which they suggest can be discomforting, unbearable, unsettling or even terrifying. It can be utterly claustrophobic and confined, evoking any of the reactions which we might feel finding ourselves utterly alone forever in a chamber which never changes.

SANITARIUM BLUE (1)
Oil on Canvas, 36" x 48", 1987.

CHARLIE (2)
Oil on Canvasboard, 20" x 24", 1987.

SHADOW UNDER THE WALL (F.P.)
Oil on Canvasboard, 20" x 24", 1987.

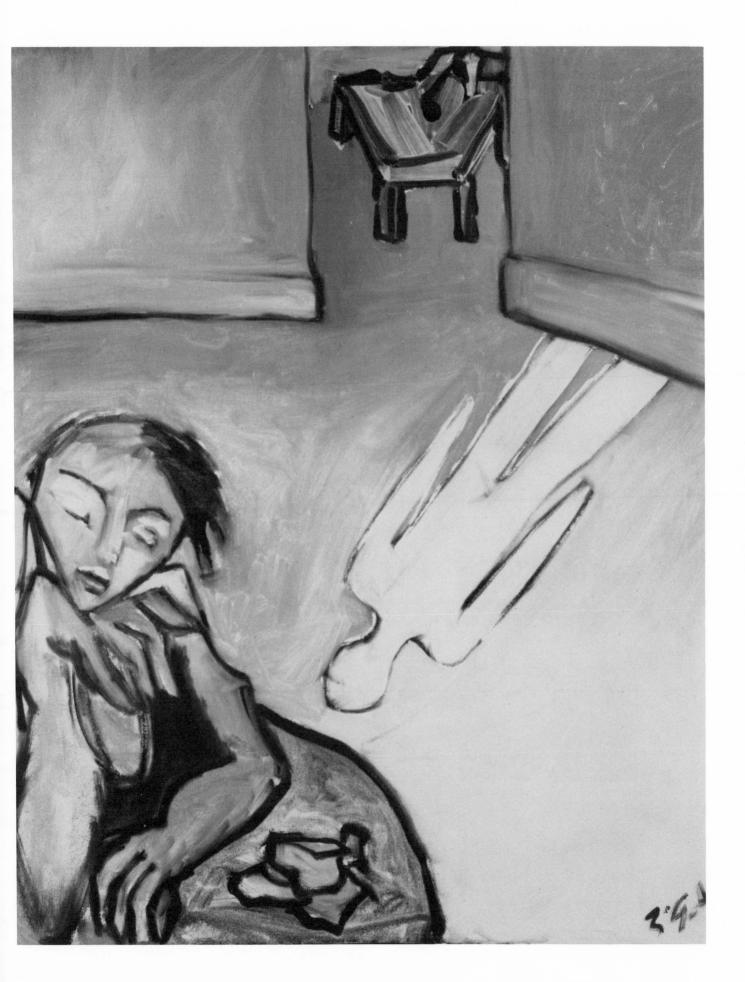

Photo Credit: Mariette Fournier

The receding labyrinth which is glimpsed through openings in the walls or through the doorways leaves us with *No Exit*. But we should not confuse these with existentialist works. In fact they are practically diametrically opposed to existentialism and its homocentric point of view. The purpose of these powerful images is not to convey a sense of despair, but rather to awaken something inside the viewer. Whichever the response, they rarely leave one indifferent.

The maze in the background *is* the fabric of the universe, it is the *time-space discontinuum*—intricate, illusory, deceptive. The maze is also a mirror, a reflection of that *One Super-enormous Chamber* that leads nowhere. The mirror image provides perspective, and distance. It also provides a unit of measurement of time, implying that even in an eternal space time can be measured in some way however objectively artificial.

As in most of his larger works, Gold denies illusionism. Instead, he suggests dimensionality from foreground to horizon through the use of forced perspective.

Although gesture forms a strong basis for this series, Gold roams through the various art traditions with his technical expertise and uses whatever feels appropriate. His facility with innovation enables him to synthesize experiments performed in Cubism and other forms of nonrepresentational art. But it is his affiliation with German Expressionism that is most apparent here.

The lines which he develops are bold, and dark. The colors are a combination of bright and murky. The ability to combine an uncontrolled explosion with a serene depth of equalized intensity, alternating light and dark moving across the canvas, allows him to reconcile these two extremes. It is often not so much that what Gold does is new in itself, but rather how he does it that makes it interesting and worth exploring.

The brush strokes are energetic and explosive. They are like a flurry across the canvas lending momentum to these already overpowering images, reasserting their content and the power of the situation. They establish a tension between the volume and corporal presence, and the energy involved, between the macrodimensional qualities and the figuration.

BEWITCHED, BEWOTHERED, AND BEWILDERED
Oil on Canvasboard, 20" x 24", 1987

OFF THE TOP OF MY HEAD/SANITARIUM MELTING (F.P.)
Oil on Canvasboard, 20" x 24", 1987.
Serigraph on Arches, 1989.

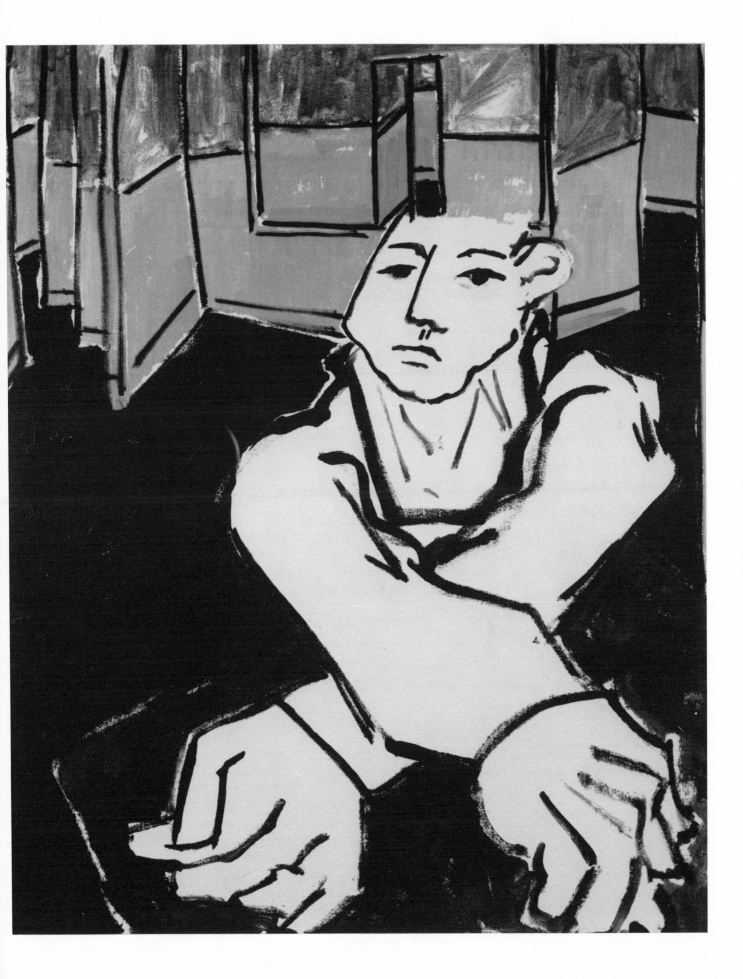

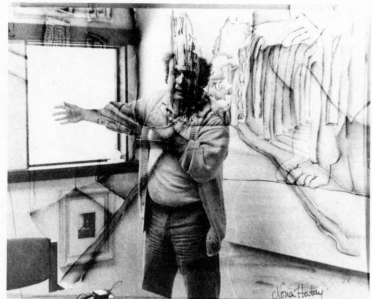

PhotoArt by Nona Hatay

"Gold is intimist and fluid. His work appeals to me. One would have to be jaded to be indifferent to it."

Carlos Godo
Art Collector
São Paulo, Brazil

Odalisques

MARC CHAGALL WITH FLOWER POT
Acrylic on Canvas, 36" x 48", 1987.

POMEGRANATE (F.P.)
Acrylic on Gatorboard, 48" x 96", 1986.

The odalisque presents as an attractive variation of an ancient artistic tradition—the study of the female. Gold has studied the image of the odalisque from neolithic pictoglyphs to contemporary depiction. And he has painted, drawn and sketched thousands of them. Yet, he has often remarked that he has come within reach of what he thinks an odalisque should say in only four or five pieces.

Are Gold's odalisques the same odalisques we have seen in the European tradition of painting and elsewhere in the world? Are they a distillation of icons of modernism? Is it only because we have seen Redon's and Monet's dream flowers, Matisse's, Gauguin's, Vermeer's and Van Gogh's interiors that these images have not only a visual correspondence but an emotional connotation for us? What is it about these paintings that forces us to have previously come to emotional and perceptual grips with their predecessors?

The odalisques can be considered gesture work at its height. They have a visual spontaneity that is truly grand and overwhelming. In these colorful paintings, Gold synthesizes the elements most typical of the modernist painting style with references to artists such as Matisse in the European tradition, and Diebenkorn in the American school, and the objects and forms that seem by necessity to dwell in these visions and form their non-sectarian symbology. But this is not what defines their merit. Beneath the attractiveness and accomplishment of these paintings and gouaches, there lies a further mystery....

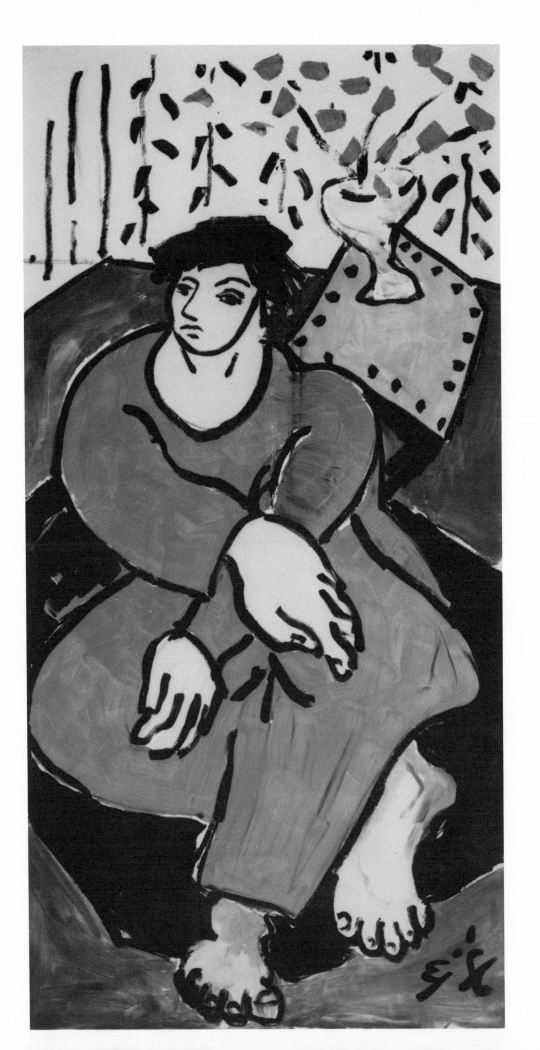

"I could easily claim that I chose this style because it most effectively produced the reactions I wanted to produce in viewers. I'm comfortable in it, and it's the style in which I do my best work. Anyone with an ounce of common sense can see that I'm not following Matisse or Cezanne. It's only to the most superficial observer that it would seem that my work and theirs are related; the relationship is very limited, defined by strict academic conventions."

E.J. Gold

The flattened perspectives and juxtaposed color areas, thick line drawing and figures in repose all echo the concerns Gold has explored in works such as his expressionist *Dark Hour* linocuts which share a common preoccupation. But it is the *Sanitarium* series which, although different in mood, are the closest to touching upon the same profoundly enigmatic questions. With the odalisques, expressions and postures are played against bright color areas and intimate decor complete with side tables, wall paper, and flower vases. The atmosphere is no longer that of an oppressive hospital ward or bland institutional corridor but one of serenity, beauty, and majesty.

In producing countless figures Gold duplicates moods and atmospheres which are in fact spaces, chambers, rooms, populated by archetypes and symbols taking the form of odalisques, monks, madonnas, creatures, monsters, beasts, demons, or angels. If we had to reduce Gold to a single genre we could say that above all he portrays eternalized beings in eternalized moments, the here and now from which there is no escape.

"A marvelous expression of E.J. Gold's artistry."

Max Adjarian
Master Book Binder
California

ODALISQUE RECLINING WITH ABSTRACT
Gouache on Society watercolor paper, 1986.
Serigraph on Arches, 1988.

ODALISQUE INDIAN FASHION WITH BLUE VASE (F.P.)
Acrylic on Canvas, 36" x 48", 1987.

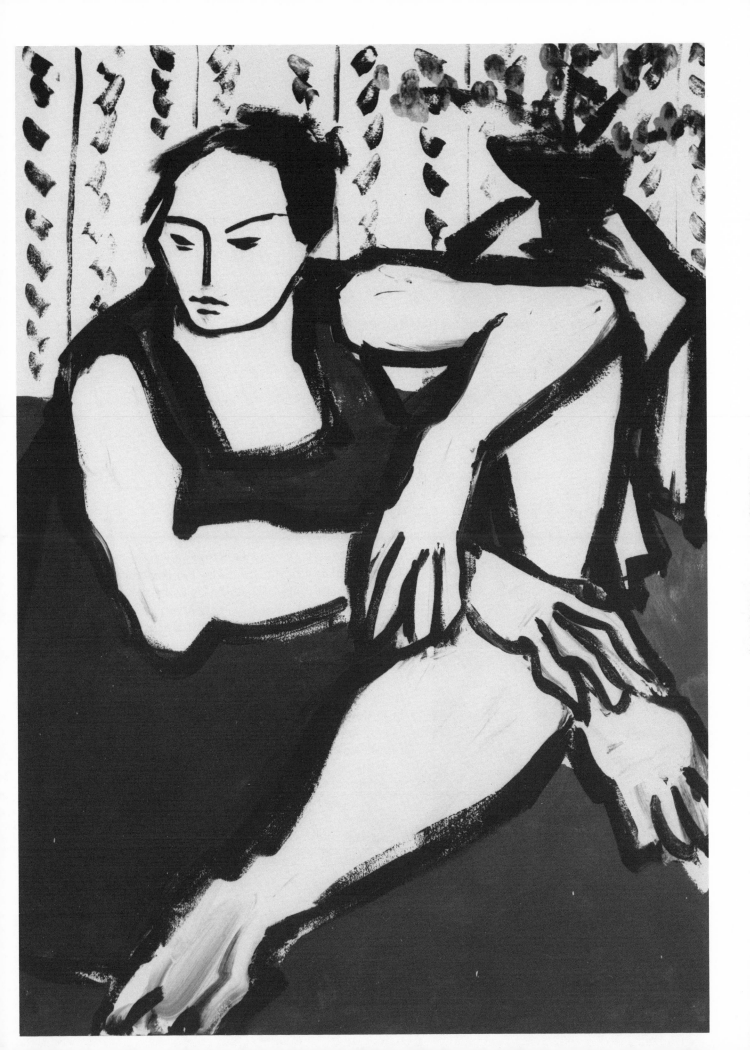

> *"Gold has modified, tweaked, and coopted so much of the tradition, from Renaissance to post-modernist work, that he emerges as an ingenious and superior deconstructionist."*
>
> —Dr. Claude Needham, Director
> Museum of Ancient and Modern Art,
> Nevada City, CA

O*dalisques* are therefore another way in which Gold invites us into a world of archetypal images in pure reductionist mode. In the image of the odalisque, he has tried to express the essential of what it is to be a woman, not the caricature of sterile femininity, nor the pseudo-romanticist view promulgated by the cosmetic and garment industry, but the true feminine ideal, the woman who cannot leave her chamber, whose lover must come to her, must find her first and then must dare the challenges of the labyrinthine path leading to her innermost self.

More than this, the odalisque is a transdimensional figure *par excellence*. It is a vortex which draws everything to itself like a vacuum; everything—all of creation both inside and outside itself.

The odalisque represents for Gold the very height of an artistic cosmology. The woman alone in her chamber is to him the most profound image of the condition of the Absolute, Her Majesty's Secret Chamber, an esoteric hiding place which we all seek and at the same time profoundly fear, unless we know Her well. The odalisque represents the chamber of the Absolute in its *Shekinah* form sitting in stillness and silence.

ODALISQUE WITH STRAIGHT HAIR (1)
Gouache on Society watercolor paper, 1986.
Serigraph on Arches, 1988.

CONTEMPLATING SCHOPENHAUER (2)
Gouache, 1986.
Serigraph on Arches, 1988.

ODALISQUE WITH CLASPED HANDS (F.P.)
Acrylic on Canvas, 36" x 48", 1987.

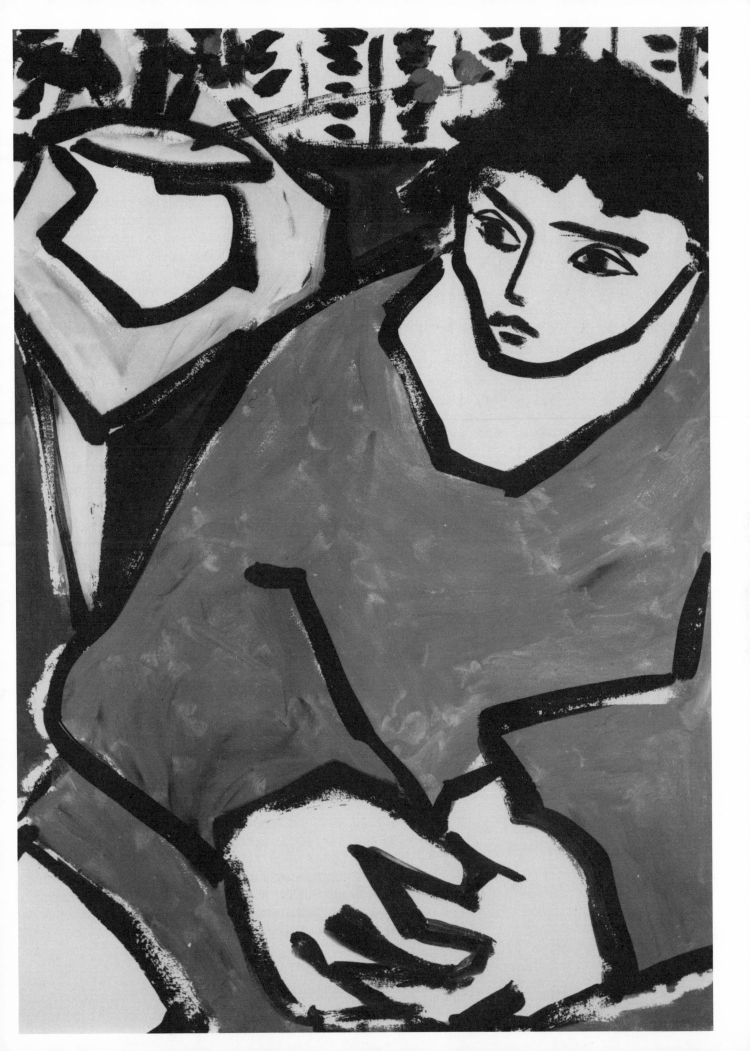

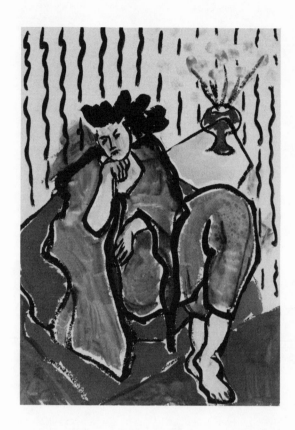

"These rooms and their residents are archetypes that we encounter in this life or another. The uncanny familiarity of the images may be not from deja vu, the memory of another such chamber, or another similar life, but rather a recall of life as one whole cloth, one single life that simply transforms its outward shimmer as a convenience to its own numerous eyes."
—Iven Lourie, Author and Critic, California

In a recent interview, Gold stated that the odalisque rests outside of time and space but is traversed by the diagonals of time and space though it does not participate in them. The hands of the odalisque are always crossed, indicating that the Absolute is affixed by "voluntary nails" to the cross of creation, bound, for the moment, by enraptured yet cosmically free and playful involvement, and by the laws of space and time—as much as any of us.

The view that Gold is expressing could be categorized as a kind of contemporary "Gnostic Shamanism." The cross for him is not a Christian symbol but a universal one preceding Western philosophy by several millenia.

Here we have reached pure symbolism not invented by an individual but existing independently. Gold is not an inventor but a vehicle for symbols which appear spontaneously in his work; in this sense, he plays the role of hermetic mediator, duplicating something existing rather than creating something which does not exist.

The other aspect of the odalisque to consider is its own point of view. The odalisque has only one inescapable point of view. Although we see it head on, from the front, in a flat space, it has the view from above. It sees itself from top to bottom.

No matter what the point of view, the odalisques reveal an unexpected intimacy; the best of them have an indescribable quality, their effect is profoundly disturbing, stirring deep tides within us, and awakening an inner response to mystery and majesty.

CONTEMPLATING THE VERY END
Gouache, 1986.
Serigraph on Arches, 1988.

GRAND ODALISQUE (F.P.)
Acrylic on Gatorboard, 96" x 96", 1986.

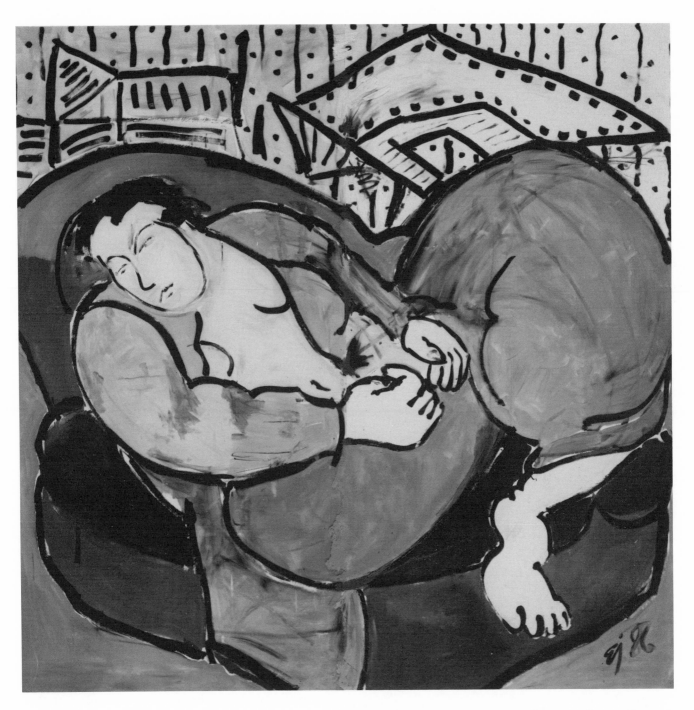

"A real art collection is a gathering of a collector's vision quest. Just as a serious artist wishes to understand where his vision is coming from, so a serious collector hopes to find out what's causing his quest, what's behind it."

—E.J. Gold

Manifesto of Reductionism

The powerful and corrupt art dealers who thrive on the pernicious concept of ART MARKETING have done everything they can to stifle the production and dissemination of ART and suffocate the courageous experimental artists who work in spite of the degenerated situation in the arts today.

The market for novelty and shock value characterized by the DOMINANCE OF THE NEW has transformed art into a faddish pursuit, a frivolous commodity yielding FEW LASTING WORKS OF ART. This trend is symptomatic of the spiritual diseases which are presently ravaging our inner fibers and eating away at our social basis.

THE SCHOOL OF REDUCTIONISM has a strident statement to make against the social, aesthetic and business corruptions surrounding the contemporary production of art but it is not limited to social comment nor is it created in reaction to this. It exists in spite of all this.

In opposition to predictably reproducible effects, facile solutions, vacuous mental meanderings, intellectual facetiousness, and decorative misrepresentations which reveal the GENERAL SPIRITUAL BANKRUPTCY of the profit-hungry individuals who have no interest in art other than a desire to CONTROL it, there are those who still believe in the concept of ART SCHOOLS, and such time-proven values as MASTERY, TRADITION, and HIGH AESTHETIC. There are those who still believe in THE POWER OF ART AS A GATEWAY TO HIGHER PERCEPTIONS.

With the arrival of APPROPRIATION ART, we have entered a truly ALEXANDRIAN period of reiteration of all the aesthetic ideas that have been previously discovered. This repetition is based on the BELIEF that we have reached the LIMITS OF ARTISTIC DISCOVERY, that there is NOTHING LEFT TO SAY, and is indicative of the GROWING DESPAIR THAT IS DESTROYING THE HOPES AND DREAMS OF OUR CIVILIZATION.

REDUCTIONISM ASPIRES TOWARD A VISION OF ANOTHER REALITY.

REDUCTIONISM recognizes the continuity of forms and languages used in artistic explorations. It refutes the illusion of an historical vacuum. REDUCTIONISM directs the attention to REDUCTIONIST ART that has been produced since the time of the first PREHISTORIC SHAMANIC VISIONS OF LASCAUX, ALTAMIRA AND AJANTA. It asserts that All ART EXISTS WITHIN THE CONTEXT OF ARTISTIC TRADITION, whether it be an EXTENSION of the tradition or a REJECTION of it.

Pop Art arises from a coldly mercenary mix of Dada, Bauhaus, Industrial Mass Media and the current CULT OF PERSONALITY just as surely as Jackson Pollock and Willem de Kooning's Abstract Expressionism arises from Surrealism, Symbolism, Zen Gesture Painting and Cubism. Those movements in turn had their basis in the study of Fauvism, Blau Reiter, Suprematism, Impressionism, Naturalism, African and Cycladic sculpture and so on. The lineage of every living painter reaches back through the history of ART EXPERIMENTS.

Before Johns and Rauschenberg and Christo and Beuys came Pollock and Kline

and Gorky. Before them Miro and Leger, Picasso and Braque, Klee and Kandinsky. Before them Matisse and Gauguin and Van Gogh, who studied Cezanne and Manet and Japanese art. The line reaches back to Renaissance and Gothic painters, cathedral sculptors and medieval illuminators; so-called primitive artists who created fetishes and ritual artifacts and images.

REDUCTIONISM brings a NEW PERSPECTIVE to contemporary art, a particular aesthetic view that REDEFINES THE RELATIONSHIPS between Artist and Artifact, Perceiver and Art Object. REDUCTIONISM is a NEW MOVEMENT in contemporary art; it is not a NEW THEORY.

REDUCTIONISM IS TIMELESS.

ARTISTS' NAMES are emblems. For every CELEBRITY ARTIST there are hundreds of unknowns doing comparable work within the various artistic modes of the time. FAME AND GAIN are relatively recent additions to the structure of the production of art. But they are the sounding bells of its death.

REDUCTIONISM recognizes SUCCESS-FUL EXPERIMENTS by artists of every era and culture irrespective of the SCHOOL OF ART, specific direction and artistic purpose espoused by the artists involved. REDUC-TIONISM cannot claim exclusive OWNER-SHIP OF THE TRUTH.

REDUCTIONISM proposes a critique of POPULAR ART, MASS ART, COMMER-CIAL ART, MODERNISM, POST-MODER-NISM and so on. REDUCTIONISM rejects art that is FOR THE PRIMATE, that caters to personality, that intends the superficial seduction of the senses of the perceiver, or the force-feeding of bank accounts.

REDUCTIONISM IS INDEPENDENT OF THE ART MARKET.

REDUCTIONISM IS INDEPENDENT OF THE ART CRITIC.

REDUCTIONISM IS INDEPENDENT OF THE ART CONNOISSEUR.

WHAT IS REDUCTIONISM?
IS WHAT REDUCTIONISM?
REDUCTIONISM IS WHAT?

REDUCTIONISM TREATS THE PRODUCTION OF ART AS A SCIENCE. More particularly, it is A SCIENCE OF PER-CEPTION. As a science of perception, REDUCTIONISM EXPLORES NEW FORMS OF PERCEPTION WHICH FORCE THE VIEWER TO CONFRONT NEW MODES OF PERCEPTION, realities which go un-noticed, ignored, forgotten, or generally avoided through whatever means common-ly serve this purpose in our ordinary sensory selection processes.

The juxtaposition of photorealism and abstraction, for example, is one way to force the perception of ANOTHER REALITY. THESE NEW PERCEPTIONS ARE IN FACT UNCONFRONTABLE PERCEPTIONS. The juxtaposition between the familiar and the unknown produces a discomforting effect which many viewers will shy away from while others will seek the novelty of the ex-perience.

The first response to a new perception is DENIAL. New forms of perception are UNCONFRONTABLE. Their encounter produces interruptions in the perceptual order and transforms them into FEAR ob-jects. Fear breeds anger as a biological response. Repetition renders any new per-ception a commonplace event automatically

transferring it into the domain of the ordinary and the accepted.

Each generation has its own PERCEPTUAL LIMITATIONS. Impositions upon these limitations have the effect of shattering the ego's equilibrium and forcing it to seek a new balance in order to restore its personal comfort. The ego, being lazy, does not like to deal with rebalancing itself and therefore all PERCEPTUAL CHALLENGES are a threat to personal inertia.

The ARMORY SHOW became important and significant not as an artistic event and breakthrough but as a perceptual problem which confronted the PERCEPTUAL STATUS QUO. The same is true of Stravinsky's *Rite of Spring*. When this work was first performed, the audience was confronted by yet another perceptual fugue it was not ready to deal with and therefore reacted very badly by tearing up the theatre.

FORCING THE EXPERIENCE OF UN-CONFRONTABLE PERCEPTIONS IS A WAY OF ACTING ON THE AWARENESS AND PERCEPTUAL APPARATUS OF THE VIEWER AND FORCING ITS EXPANSION THROUGH EXPOSURE AND REPETITION.

REDUCTIONISM PRODUCES DISCOR-DANCE AND DISSONANCE.

ART AS SCIENCE means that artistic production is EXPERIMENTAL in nature and free from marketing constraints and de-mands. ART AS SCIENCE means that ex-perimentation has a specific purpose and that knowledge and understanding are necessary to accomplish the experiments carried out in any given program. ART AS SCIENCE means that ALL ART EXISTS IN CONTINUITY.

WHEN WE BEGIN a REDUCTIONIST work we generally start from a natural form, a form suggested by nature. This is our FIRST FORM. It can be mathematical, geometric, whatever we perceive or choose to perceive as "nature." We begin with natural patterns that are recognizable to the primate human being.

THE FIRST FORM leads to transitional forms, intermediate passages that the artist works through to arrive at the REDUC-TIONIST work. There is no set number or principle of passages, just as there is no limitation of media that a REDUCTIONIST artist may employ. There is REDUC-TIONISM in sculpture, in dance, in poetry, in theater, in music as well as in the visual and graphic arts.

HOW MANY PASSAGES will the artist need? As many as it takes to reduce the FIRST FORM to THE ABSTRACT, defined as THE FORM THAT IS USUALLY REJECTED BY THE PRIMATE PERSONALITY.

THE REDUCTIONIST WORK is reduced only in the sense that it is STRIPPED OF FORMAL CLICHÉ AND SEN-TIMENTAL REFERENCE. THE STRUCTURE presented by a REDUCTIONIST work is vague, indefinable, confusing to the PER-CEIVER AS PRIMATE, BUT ATTRACTIVE, COMPELLING, EMOTIONALLY EXPLICIT ON ANOTHER LEVEL.

ALL ABSTRACTION IS NOT REDUC-TIONISM. An abstract work is REDUC-TIONIST to the degree that it approaches the ABSTRACT ABSOLUTE in form.

WE BEGIN WITH A FIRST FORM and proceed to evaporate, crystallize, dissolve, coagulate or transform it. We might take an intermediate reduction from one form to

another and further reduce the resulting form. This might produce a work which is not what we're seeking. REDUCTION TO THE ABSTRACT can be done in numerous ways, and not all will yield the REDUCTIONIST result. MINIMALISM is a form of abstraction which is in general—but not always—antithetical to REDUCTIONISM.

IN THE SCHOOL OF REDUCTIONISM, THE ABSTRACT IS DEFINED AS THE POINT AT WHICH THE PRIMATE REJECTS THE PERCEPTION OF ANOTHER REALITY.

THE PRIMATE LOVES FIGURATIVE ART, recognizable patterns and photo-realism. It feels safe when surrounded with familiarity, and automatically translates into reflections of itself anything that it can name. Because of this, it will name everything it encounters in order to place it in a permanent slot and bind it in the realm of the known. Mental patterning and the need to name causes the loss of perceptions of other modes. FEAR OF THE ABSTRACT IS FEAR OF THE WAKING VISION—FEAR OF DEATH from the primate perspective.

Permanent museum installation may serve as a PRIMATE DEFENSE against abstract art that is too successful in a REDUCTIONIST mode.

REDUCTIONISM ALLOWS FOR COMPLEXITY as in Marcel Duchamp's *Nude Descending a Staircase,* which is abstract and REDUCTIONIST. If the OVERALL QUALITIES AND CHARACTER of a work of art are rejected by the primate, IT IS REDUCTIONIST. THE PRIMATE WILL IMMEDIATELY BEGIN TO DEFEND ITSELF against a piece in any medium which is a successful attempt at REDUCTIONISM, because it is threatened by this vision.

HISTORY WILL TAKE ITS TOLL in regard to the impact of REDUCTIONIST masterpieces. While Cycladic sculpture may fluctuate radically on the market, and suggest a commonplace APPROACH TO ABSTRACTION, the strength of the best Cycladic pieces will tend to remain free of market influence.

Nude Descending a Staircase, on the other hand, may have the potency of its iconography as abstraction reduced by the TRANSLATION OF THE RESULTS of Duchamp's experiment (like Man Ray's, Andre Derain's, Vincent Van Gogh's, Chaim Soutine's) into a market commodity or FETISH.

WE MUST DIFFERENTIATE BETWEEN A REDUCTION TO THE AESTHETIC ABSTRACT AND A REDUCTION TO THE VISUAL ABSTRACT. Simplicity is not the issue. Minimalism is not the ultimate in form. REDUCTION may be accomplished in painting by simplification, color field abstraction, elimination of detail, distortion of perspective and form, and dimensional illusion. It may also be accomplished BY MORE SOPHISTICATED OR SUBTLE METHODS as yet undiscovered. The artists who sign this MANIFESTO have all successfully achieved the REDUCTIONIST abstraction, but none claim to have exhausted its potential for experimentation.

REDUCTIONISM IS AN OPEN FIELD. The definition of REDUCTIONIST Art as determined by an inner response to abstraction is necessarily ahistorical and atemporal. REDUCTIONIST WORKS MAY BE

DISCOVERED as well as created in all media presently existing and those not yet invented.

REDUCTIONISM MAY BE DEFINED AS A HIGH AESTHETIC WHICH EXISTS INDEPENDENTLY OF HISTORICAL OR COMMERCIAL CONSIDERATIONS. WE CREATE OUR SERIOUS WORKS AS AN ICONOGRAPHY OF CONTEMPORARY SPIRITUAL AWARENESS. WE AS ARTISTS CHALLENGE YOU IN THE INTERNATIONAL ART COMMUNITY TO DO THE SAME IN THE FACE OF ALL PRESSURES AND INFLUENCES THAT WILL ALWAYS SUSTAIN THE PRODUCTION AND DISSEMINATION OF PRIMATE ART.

THE ARTIST WHO PRODUCES REDUCTIONIST ABSTRACTION DEVELOPS AND EXERCISES SHAMANIC VISION.

THE NAMES OF THE PAINTERS OF ALTAMIRA HAVE BEEN FORGOTTEN BUT THEIR WORK STILL SPEAKS TO US TODAY.

IT TOOK A BICYCLE TO BRING ART INTO THE 20TH CENTURY. IT WILL TAKE AN ELEVATOR TO GET US OUT.

WE THE UNDERSIGNED ARTISTS OF THE SCHOOL OF REDUCTIONISM invite practicing artists of every nation and culture to participate in the ongoing experiment of REDUCTIONISM. We assert the universality of the principles and means of this school, and above all insist that REDUCTIONISM IS NOT DEPENDENT UPON MODES OF ART PRODUCTION PARTICULAR TO ANY CULTURE OR SOCIAL GROUP. Lack of capitalization or of access to the international art market network is no obstacle in regard to producing REDUCTIONIST works.

ZOE ALOWAN
AVIKO
STEPHANIE BOYD
ROBBERT CAMPBELL
DAVID CHRISTIE
NANCY CHRISTIE
LINDA CORRIVEAU
WILLEM DE GROOT
PARKER DIXON
MARK EINERT
TIM ELSTON
JULIA GLASSE
E.J. GOLD
RICHARD HART
KAREN HELLMICH

DELLA HEYWOOD
WAYNE HOYLE
TOM JOHNSON
TABATHA JONES
ROSE MARIE JODOUIN
KAY KLAMMER
IVEN LOURIE
MENLO MACFARLANE
CLAUDE NEEDHAM
LILY NOVA
KELLY RIVERA
VICTOR ST. JAMES
RUDY UDARBE
SCOTT WELLMAN
WALBURGA ZIEGENHAGEN

E. J. Gold

E.J. Gold was born in the midst of the intelligentsia of the 40's and 50's in New York. His father was the editor of the famous *Galaxy* magazine, while his mother was a writer and dancer. He grew up surrounded by the Who's Who in the arts and sciences in America: Isaac Asimov, Arthur C. Clarke, Robert Heinlein, from the field of science fiction; Julian Huxley, an intellectual and scientist of the first order; John Cage, Merce Cunningham, Pete Seeger, Oscar Levant, Ferde Grofé, representing music and dance; Charles Laughton, Orson Welles, actors of the highest calibre, and Bruce Elliot, a magician's magician. These names are but a sampling of the luminaries he encountered early on.

A precocious child, Gold was encouraged to draw by Ben Shahn, another family friend,

Courtesy of Museum of Modern Art

and eventually participated in the innovative *Children's Art Carnival* sponsored by the *Museum of Modern Art*. He had his first public exhibit in 1948. Inspired to develop his many talents, young Gold was never restricted to one domain and as an adult has been successful in a wide variety of ventures.

In the late fifties, he frequented the *Cedar Tavern* and other bohemian hangouts, and was one among many who met with Kline, de Kooning, and the circle of artists at the center of the latest developments in modern art.

Dissatisfied with the direction in which the New York scene was heading, Gold moved to Los Angeles in the early 60's, and studied at the Otis Art Institute, perfecting his classical background. He returned briefly to Otis to

teach. Even as a student Gold distinguished himself among his peers, and teachers like ceramic-sculptor Bob Glover remember him as being "the kind of student that makes teaching worthwhile."

Courtesy of Otis Art Institute

Before he had completed his studies, Gold began participating in group shows, and soon made a name for himself synonymous with inventiveness and imagination. He became widely recognized for his invention of soft and breathing sculptures. His remarkable collages and sculptures where he treated art as found objects were considered highly controversial experiments at the time.

During the sixties, he was represented by Robert Comara Gallery in the La Cienega district. Comara sold Gold's work as fast as he could produce it, and in no time at all he was famous within the California Nine, a group of loosely connected artists including Shiro Ikegawa, Max Cole, Frank Stuck and Robert Hansen.

Courtesy of Houston Chronicle

Exhibits of his art took place across the country and several museums displayed and acquired their first Golds, thus officially endorsing his

iconoclasm and consecrating him as an artist. Like much of the art of the 60's, records of these transactions have been dispersed with the death of gallery owners, personnel turnovers in museums and loss or change of filing systems. Only a few early works have been located.

During this period, Gold worked with Rico Lebrun and Fritz Schwaderer, two powerful artists who provided him with depth and seriousness, and nurtured him under their umbrella. Lebrun reinforced his classical aesthetics and taught him something about conveying the power of emotion. He elevated the treatment of the human figure to a universal level which corresponded to Gold's own emerging views.

Schwaderer touched a different sensitivity. He deepened Gold's appreciation of and natural attraction to German Expressionism, by widening his understanding of its structure. He also provided him with a rich palette of colors, traces of which can be found in his work to this day.

The late 60's and early 70's led Gold in many directions including performance art, happenings, and art "events." For example, he and his Otis cronies staged "Earth Day" which is now celebrating its twentieth anniversary. Later there was the organization of the Committee for the Non-Suppression of 40 Demoted Saints and their picketing of the State of California Department of Employment dressed in apparel appropriate for saints.

Courtesy of New York Times Magazine

Gold's events were successful media attractions which never lacked a sense of humor. Even *TIME Magazine* reported on them.

The most famous event occurred when Gold, as a member of the Fellowship of the Ancient Mind, a telepathic society supposedly 6,000 years old, staged the Great California Earthquake. The event generated over 2,000,000 words in print in magazines and newspapers including the *LA Times, LA Free Press,* newspapers throughout the country, Associated Press, Reuters, *TIME, Newsweek, Paris-Match,* and *Stern.* Media coverage also included Huntley-Brinkley and Walter Cronkite.

The *New York Times Magazine* in a five-page article had this to say on April 6, 1969: "The Fellowship caused a bit of a stir recently when several members appeared at Los Angeles City Hall and applied for a salvage permit that would allow them to rescue great works of art when an earthquake strikes.... The group's plan is to send objects out of state by teleportation...." The initial coverage appeared on April 1st, but no one seemed to have noticed that it was timed to coincide with April Fool's Day.

The Fellowship later announced that it had abandoned its project having discovered that there was no great art in Los Angeles. The spoof was actually a comment on the Los Angeles County Museum of Art which was scorned by artists for being "a first class building with second class art by first class artists."

The Fellowship was in fact a technical advisory service which did research into the occult, the supernatural and unexplained phenomena for the motion picture and television industry. Universal Studios employed Gold as a consultant. One project was *The Name of the Game,* an episode starring Gene

133

Courtesy of Universal Studios

Barry, Jose Ferrer, William Shatner, Bethel Leslie, and David Carradine.

These forms led Gold into music and video production, television writing and consulting for many well known series such as *Get Smart,* and *Man from Uncle.* During this period he also did a considerable amount of writing in the field of science fiction and fantasy. His published SF credits include *Galaxy* and *OMNI.*

Having turned his attention to transformational psychology a number of years earlier, Gold began publishing books in this field. At the same time as these changes were occurring, he also decided to withdraw from gallery exhibits as a protest against the corruption of the artistic milieu. From that point on, he basically went underground and stopped showing his art.

But Gold's creative outlets never ceased pouring forth, and he continued to be as productive as ever in the most diversified areas. In fact it's hard to define what Gold has *not* tried his hand at—usually with a considerable degree of success. He has been at times jeweler, stock portfolio consultant, stand-up comedian, jazz club manager, stage magician,

professional recording and production engineer for several major singers and groups, magazine editor, dancer, musician, composer, stage director, theoretical physicist, think-tank consultant, television writer, museum curator of antiquities.... The list goes on and on.

Almost twenty years later, in the late 80's, after being persuaded to allow his art to circulate through the gallery network again, Gold reemerged and entered a prolific artistic period boldly reasserting himself as an experimental painter and sculptor. His diversity and proficiency are notable. Sculptures, oils-on-canvas, acrylics, ink washes, pastels, gouaches, charcoals, linocuts, serigraphs, lithographs, monoprints, pen and inks—all clearly demonstrate his fertile imagination, technical expertise and uncompromising discipline.

Gold makes every effort a finished work. He boldly and candidly asserts his indefatigable humor coupled with classicism of line and gestural mastery. All of his recent pieces reveal a talent and success resting on highly controlled draftsmanship. In fact, his trademark has come to be known as *Pure Gesture*—from which derives the title of this book. His lines are sweeping, precise, and utterly classical; his compositional adeptness unquestionable.

The moods he evokes change with the same alacrity he manisfests in changing his palette. His adaptability from one medium to another allows him to range from colorful and playful to somber and haunting. In his bolder pieces, large surfaces and oppositions of shapes and color-field often achieve striking kinetic results.

Publications of the most diverse nature feature his artwork, including books in psychology, sociology and theatre; whether it be a college textbook like *Society's Problems* by

D. Stanley Eitzen, or proto-analyst Claudio Naranjo's *Ennea-type Structures* using many of his portraits to illustrate different psychological types, or a theatre book such as Mummenschanz mime Mark Olsen's *The Golden Buddha Changing Masks*, Gold's work is ubiquitous.

Several literary classics and classics in the field of science fiction are also slated for publication with his artwork. This reflects Gold's own love for fine and rare books which he has collected ever since being introduced to incunabula many years ago by the great book dealer, the late Jake Zeitlin.

Gold is a true voyager in the heroic tradition, always keeping the highest aims and the purest ethics close to his heart throughout his explorations. His life story is a veritable odyssey through contemporary society, an adventurous journey to unlock inner secrets which he learned to skillfully communicate to others. He is internationally reputed as an originator of contemporary processes of transformational psychology and a masterful proponent of proven ancient methods of labyrinth voyaging.

Gold has authored many best-selling titles including *American Book of the Dead*, *Life in the Labyrinth*, *The Human Biological Machine as a Transformational Apparatus*, *The Seven Bodies of Man*, and *Visions in the Stone*, all copiously garnished with his artworks. Several of these have been translated and published in different languages.

One of his more charming publications is *Miro's Dream*, a bestiary passion play disguised as a whimsical series of line drawings inspired by Miro's starving artist period in Paris. This book is a survey of one facet of Gold's art. Several other introductions to his art are currently in preparation.

Aside from this type of publication, Gold has produced several portfolios and *livres d'artiste* generously replete with original art. He is presently collaborating on an international artist book combining art and fine literature with other artists of renown.

Gold is a perceptual scientist who uses art as his primary investigative tool. He is the principal contributor to the *Manifesto of Reductionism* published jointly with a circle of artists called the Grass Valley Graphics Group. Together they have made a bold statement about artistic Reductionism, according to which the least amount of visual elaboration possible allows the greatest personal perception stemming from stored perceptual patterns, previously experienced visual and emotional stimuli, and, most of all, the *viewer's experiential expectation*. The *Manifesto* was warmly greeted by artists and public alike who feel aesthetically offended by the current money-market dominated art scene.

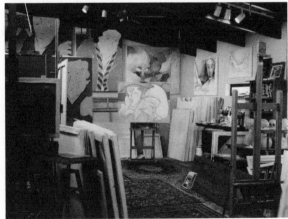

Photo by Willem de Groot

Gold's work often violates scale, at once denying dimension and perspective. By making use of color, form, texture, negative space, forced perspective, compressions, color field, figure-ground relationships, brush stroke, and

unique compositional elements, ranging from the monochromatic to the expanded palette, from two-dimensional to three-dimensional explorations, from extreme miniature to heroic proportion, Gold creates a panoply of impressions for the viewer.

At the foundation of his work are the iso-magnifications of Franz Kline, the color-field simplicity of Matisse and Cezanne, the fluidity of Picasso, the visual dynamics of Shiroge and Mu-chi, and the black outline of some of the German Expressionists. But Gold also relies upon the facility of line developed by the Dutch masters, the elegance of form extracted from the Barbizon and the suggestive non-delineated form of the Impressionist school, liberally summoning whatever knowledge he can extract from tradition.

Gold has produced many bronzes and marbles of superb elegance and fearsome strength, among the best of which are the *Jester, Mayan Lady, Dancer, Cubist Torso, Medusa,* and the heroic *Blaue Reiter.* He has also spearheaded with success a project to save an important art foundry.

At the same time Gold was developing his recent repertoire of images, his own disarmingly fresh and candid romp through the fields of modernist and post-modernist idiom, he applied the same controlled frenzy to composing a large and diversified body of musical works ranging from jazz to classical. When

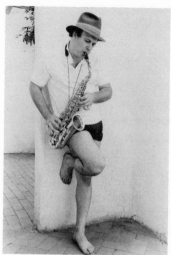
Photo by Willem de Groot

Gold turns to composition, his artistic statements and postures translate into a language which uniquely blends jazz and classical styles, handling dissonance, sophisticated temporal elements and motivic interplay with elegance and inventiveness.

His experimental music centers on sound as a vehicle for exploring inner spaces. He is an innovator like John Cage and Harry Partch. Some of his more popular titles include, *Live at the Philharmonic, Fourth Dawn, Childhood's End, Spacing Out,* and *Dance of the High-Tech Shaman.*

Gold has also been the subject of several video interviews capturing him in the midst of painting and sculpting. These interviews are rare moments when Gold is willing to talk about his art. These colorful and dynamic explorations provide fine introductions to the work of this daring experimentalist who views his studio as an alchemical laboratory and is one of the outstanding artists in this country today. They are yet another statement of his talent and inspiration.

Linda Corriveau

It would seem that from its inception, Linda Corriveau's career started at the very top, as the Director of a pavilion at Man and His World, Montreal, the site of the legendary *1967 EXPO*.

Strange, Strange World, as it was called, presented in a highly dramatic setting questions at the frontiers of knowledge and science. Research for her groundbreaking exhibits put her in contact with sought-after Nobel Prize winners, erudite scholars, respected scientists, famous writers and researchers.

The themes she delved into and explored were extremely diversified, reflecting her own interests in a wide variety of subjects. They included archaeology, astronomy, space exploration, biofeedback, unexplained phenomena, parapsychology, UFO's, advanced technologies, holography, and countless others.

The exhibit typically attracted more than 250,000 visitors for the two-month period it was open each summer during the five years she was its director.

After this early exposure to working with some of the best designers in Canada, Corriveau, a bilingual French Canadian, went on to work as a design consultant for a variety of topnotch museums, including the *Cartier Historical Museum* in Montreal, and the *Tyrrell Museum of Palaeontology*—the largest palaeontology museum in the world—in Alberta's haunting badlands.

Her views on museum exhibits became more widely recognized when she delivered a paper at a seminar on science museums and the new trends in museology at an annual meeting of the Association for the Advancement of Science.

Corriveau subsequently branched out into television reporting, scientific journalism for popular science magazines, book translations, computer manual editing, and editorial consultation for everything from a dance journal specializing in traditional Indian Kathakali dance to a magazine exploring contemporary religious phenomena in North America.

Another significant step was taken in her career when she turned down an offer to work on the biggest science museum in the world, the *Cité de la Villette,* in Paris. In typical fashion, she opted for innovation rather than prestige by moving to California, where she became the designer for the *Museum of Ancient and Modern Art,* a small but dynamic museum.

There she soon got captivated by the beauty of ancient Western Asiatic jewelry and in no time at all was instrumental in establishing *Jewels of Ancient Lands,* a jewelry company whose designs are inspired by the ancient. The company has made a name for itself based on its exquisite designs and fine craftsmanship. Its one-of-a-kind jewelry is sold in museum gift shops and fine galleries throughout North America and Europe.

Aside from preparing exhibits, Corriveau now acts as an auctioneer for the *Museum of Ancient and Modern Art's* Fine Art Benefit Auctions, a challenging function which is both demanding and enjoyable to her.

Throughout these exciting developments, Corriveau has maintained a high profile in writing which she feels provides a balance in her hectic life. Other projects to which she has devoted herself include editing the Gateways Fine Arts Series with *Miro's Dream* as a starter, and two of Gold's best known books in the area of transformational psychology, *The Human Biological Machine as a Transformational Apparatus,* and *Life in the Labyrinth.*

Nona Hatay

Nona Hatay was born in Giffnock, Scotland, on October 17, 1947. She spent her childhood traveling throughout Europe with her mother, an international expert on 19th and 20th century prints and her father, a physicist and inventor, who made his living as a self-employed think-tank throughout Europe.

Exposed to various cultures and lifestyles during her most impressionable years, Hatay imbibed a spirit of experimentalism and a fondness for incorporating divergent elements in the art of photography which she began to pursue early on. At the age of 18, she set off for Germany in search of a teacher of photography.

Almost immediately upon arriving in Munich she was accepted as a student by Fraulein Bertha Himmler, doyenne of portrait photographers, and a leading figure in the Bauhaus movement. Hatay proved an eager student, willing to learn the fine points of classical photography, while infusing her work with flair and originality. Fraulein Himmler was later to refer to Hatay as her most talented pupil.

From the beginning of her career, Hatay has relentlessly explored ways to reveal movement in stillness, to "communicate more about a subject than seemingly could be communicated in 1/30 of a second."

She has worked extensively with "expanded printing"—manipulating negatives to create in-depth photographic portraits, usually of artists or musicians. Through collage-like juxtaposition of negatives depicting an artist in various poses and including examples of the artist's own work, she ingeniously conveys the sense of the individual's creative spirit.

She has successfully worked with the process of solarization, creating effects ranging from otherworldly science fiction-like landscapes to classical pieces with a texture of ancient Chinese brocade. She has also created the photographic equivalent of abstract paintings using fractioned images which she variously combines to produce non-linear emotive impressions.

In 1987, Hatay began applying color to her black and white photographs, using watercolor, crayons, bits of material and found objects. Combining photographic realism with diverse artistic media Hatay achieves a wide range of effects including fantasy, surrealism, irony and gentle humor.

Hatay has skillfully combined pure art and professional photography. She has worked for numerous newspapers and magazines as well as CBS, RCA and Channel 13 in New York City, and has published limited edition portfolios of interactive photographs. From 1986-88 she owned and operated *Moments in Time* Gallery.

Hatay has been exhibited in numerous galleries and has become well-known for her interpretive illustrations of music. The publication in 1984 of her book, *Jimi Hendrix, The Spirit Lives On...* was a landmark in her career, bringing her recognition by a wide audience both at home and abroad, and establishing once and for all that Hatay ranks among the very best contemporary American photographers.

To produce her photoart essay on Gold, Hatay spent a week at his estate in California. Keeping up with his pace proved a delightful challenge as the artist bounded from art studio to music studio and back again, working first on a painting, then on his latest musical recording, then on one of his sculptures in progress, until well into the night. The photographic essay which resulted brought critical acclaim. Hatay has miraculously reproduced the ambience and mood of the artist in numerous aspects and postures.

Alphabetical List of Images

Fine Art/Poetry

MIRÓ'S DREAM

INTERPRETIVE DRAWINGS BY E.J. GOLD

POETRY BY IVEN LOURIE

Miró's Dream is a labyrinthine voyage, a skilled operation of spiritual-midwifery at its aesthetic height guided by overstatement, exaggerated soliloquy, emphatic dramatization, as well as droll understatement by a master of the ironic.

Levity is a disguise for gravity . . . Fanciful creatures cloak the cosmic dance of life and death in this extraordinary Bestiary Passion Play.

Inspired by Miró's "starving artist" period which so greatly influenced the formal language of his later art, artist E.J. Gold has, more than sixty years later and in the context of neo-shamanism, daringly utilized motifs dominating Miró's hallucinatory art. With skillful draftsmanship, irreverence and whimsy,

these figures have been brought to life in a dream-like setting.

American poet Iven Lourie has written accompanying poems which reflect the depth of the artist's intentions. His poems provide keys and a mood which can help us to perceive what evades verbal description and analysis. The poems have a life of their own, but share the same inspiration. This marriage of text and image imparts a haunting quality which deepens with every turn of the page.

— *Linda Corriveau, Series Editor*

GATEWAYS FINE ART SERIES
PO BOX 370, NEVADA CITY, CA 95959, 916/477-1116

$16.95

ISBN: 0-89556-055-0